KU-617-922

TAPE

AN EXCURSION THROUGH THE

WORLD OF ADHESIVE TAPES

made with Artists, Designers, Journalists and me

Die Gestalten Verlag, Berlin

Tape

An Excursion Through The World Of Adhesive Tapes

By Kerstin Finger—www.kekiretta.net

Edited by Robert Klanten, Mika Mischler and Sven Ehmann

Coverphoto by Blitzwerk.de

Published by Die Gestalten Verlag, Berlin, 2005

━━━━

Bibliographic information published by Die Deutsche Bibliothek

Die Deutsche Bibliothek lists this publication in the Deutsche Nationalbibliografie;

detailed bibliographic data is available on the Internet at http://dnb.ddb.de

© dgv—Die Gestalten Verlag GmbH & Co.KG, Berlin 2005

ISBN 3-89955-088-9

All rights reserved. No part of this publication may be reproduced or transmitted

in any form or by any means, electronically or mechanically, including photocopy or any

storage and retrieval system, without permission in writing from the publisher.

For more information please check www.die-gestalten.de

Respect copyright, encourage creativity!

ARTISTS AND DESIGNERS CHAPTER

DO-IT-YOURSELF CHAPTER

TAPE ILLUSTRATIONS CHAPTER

TEXT CHAPTER

INDEX ETC.

ARTISTS
DESIGNE
CHAPTER

———

AND
RS

TAPE WORK

by Martí Guixé— Berlin [DE] and Barcelona [ES]
www.guixe.com

Do Frame is a tape that makes it possible to do something as contemporary as allowing each individual to develop his or her own museum. **Autoband** I did in reaction to a commission from the architect Joaquim Ruiz Millet [Galeria H2O] to make a toy. Fascinated by the idea that the first experimental length of motorway is the AVUS, which I frequently traveled on in my comings and goings from Berlin, I made the tape. It is a home toy to play »highway construction« where children learn abstract concepts such as politics, lobbying, public relations, public opinion, ecology and territoriality. The pattern on the tape is a three-lane highway printed on a scale of 1:250. **Football Tape** was made for the Saint-Etienne Biennale, knowing that the team in the city is one of the most popular in France [Les Verts]. It's a tape with football pattern and looks like a football when you roll it up. **CIA Communicacion Barcelona** Joan Armengol requested that I do some sort of installation in the entrance way. I proposed a »Taping« action, where all the walls of the agency were covered in adhesive tape. Guest tape, relax tape, plant emulator 1.0 tape and others refer directly to CIA Communicacion and its concept of teamwork. **Guest Tape** A tape where you can sign or leave a message with the date, and useful as a wall guest book. **Relax Tape** A tape with facial exercises for when you are stressed, you just follow the tape instructions and then you can finally relax. **Plant Emulator Tape** Normally in offices and domestic interiors the use of plants is purely decorative, with the plants function reduced to the task of providing a blotch of green colouring. Plant emulator emulates this function by creating a green blotch without needing the plant, thus preserving the function while doing away with the object. **Exhibition view 1:1, Spazio Lima, Milan 2003** An exhibition in Milan during the »Salone del Mobile« within the context of the fuorisalone. The idea was to turn the gallery walls into objects by means of the installation of the sequence of various adhesive tapes with a concrete function all along the perimeter. In this way a totally unusual space was created during the salone, a space without objects in the center, but pushed out to the periphery. **Sketch Tape** A tape for sketching. **Forever Agenda Tape** A tape that you write the days, months and year that you can also use as an agenda.

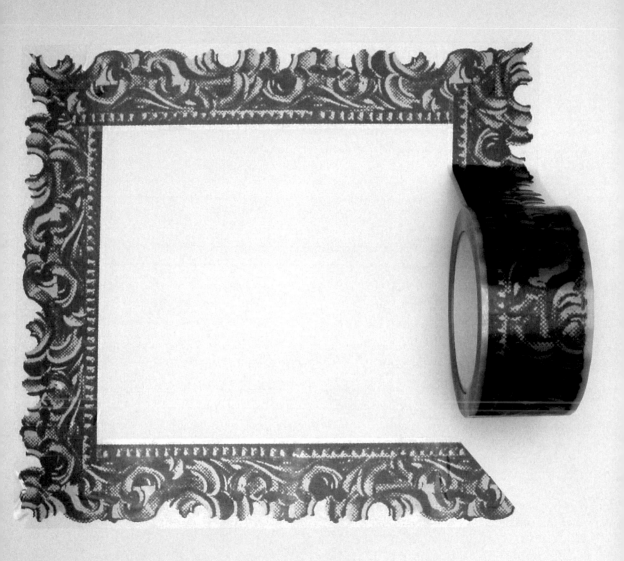

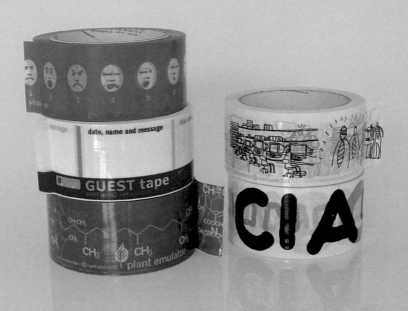

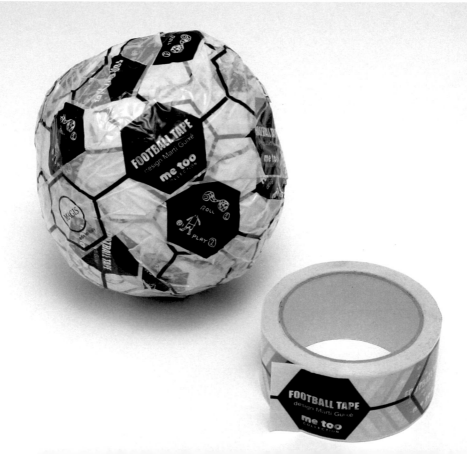

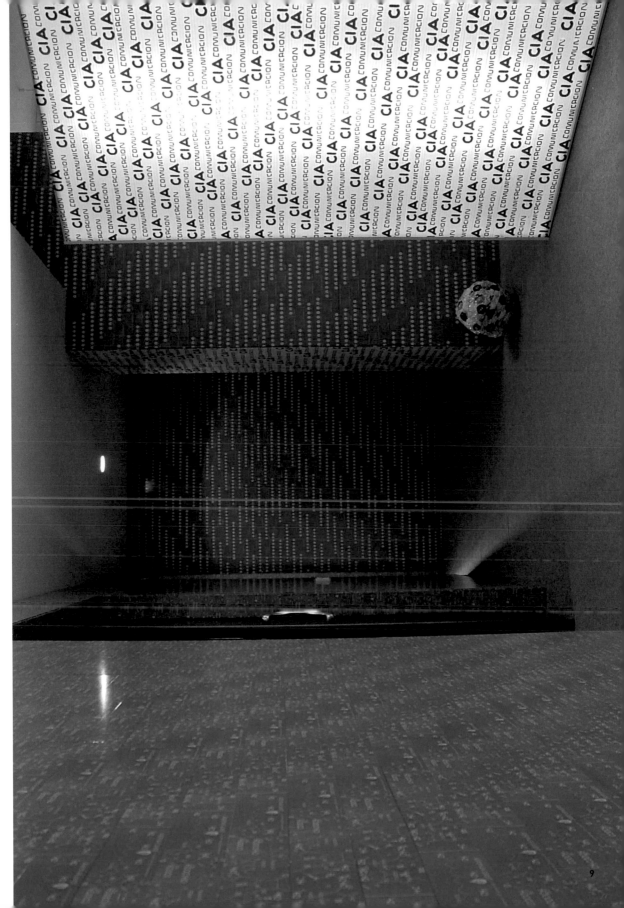

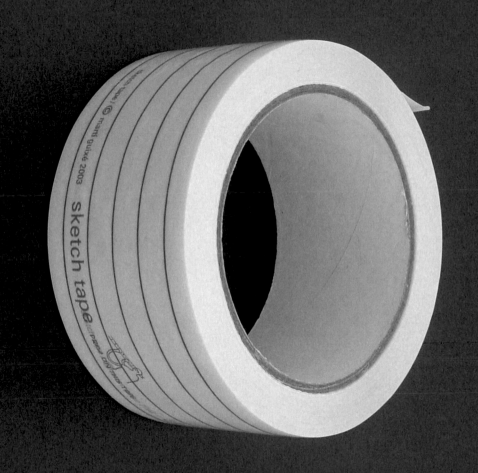

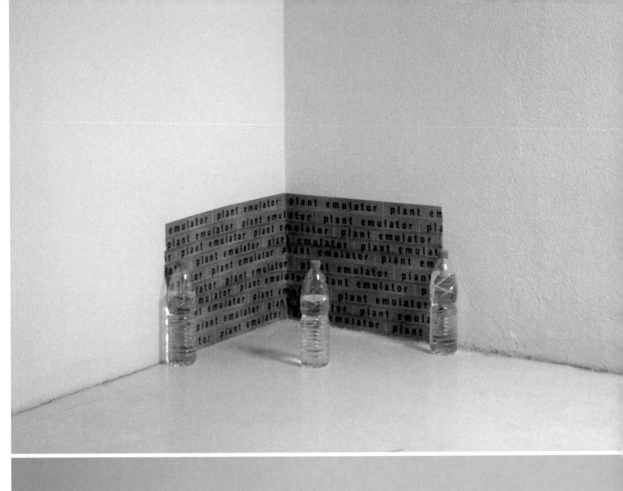

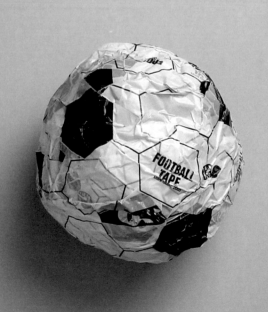

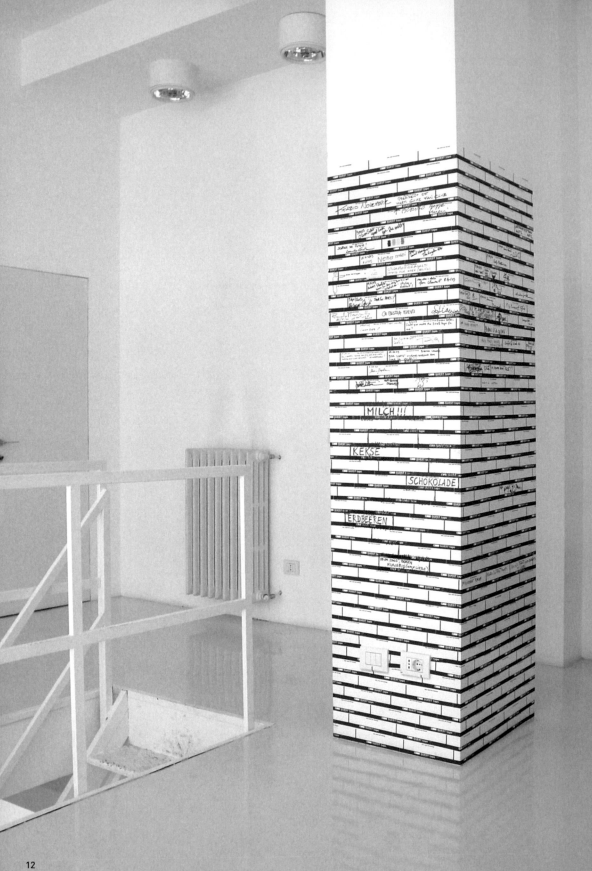

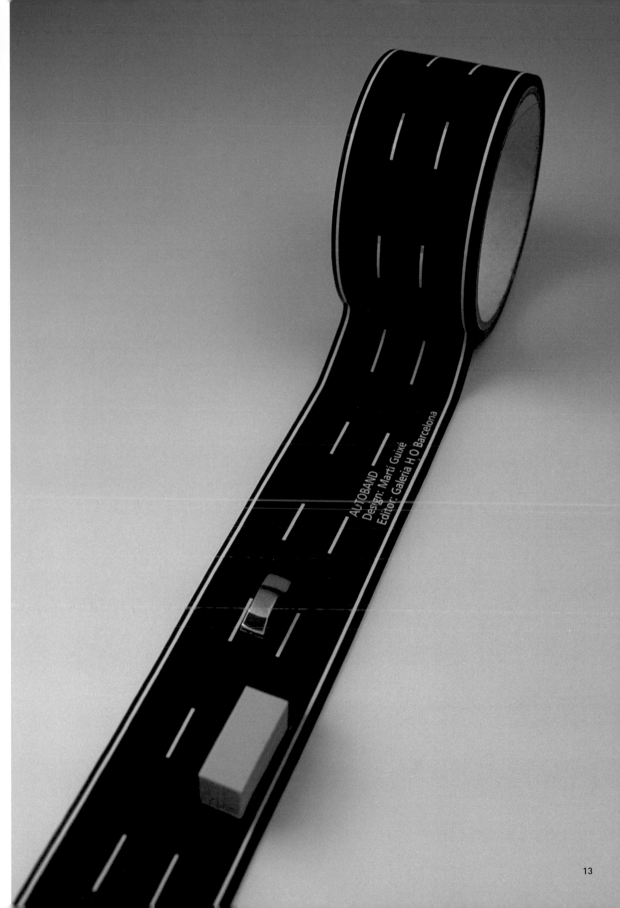

AUTOBAND
Design: Martí Guixé
Editor: Galeria H O Barcelona

13

TAPE

by Grit and Jerszy Seymour—Berlin [DE] and Milan [IT]
www.t-a-p-e.com

No sewing, just tape. A clothing concept by Grit and Jerszy Seymour. Traditional stitching is replaced by tape. A collection of t-shirts, sweatshirt suits, cashmere sweatshirts and bikinis are held together by tape. Tape is graphic, multicolor and sometimes invisible with double-sided tape.

The idea was to reconstruct the future with a little bit of love and tape. »Tape« is a collection of clothes held together by a super tape ready to battle for good and evil, to create clothes for the post industrial superhero, funky frankenstein and sexy pink pantheress in all of us. A new technique, the result of a subverted experiment. »Tape« is permanent, stretchy and washable. Peace, love and fight the power.

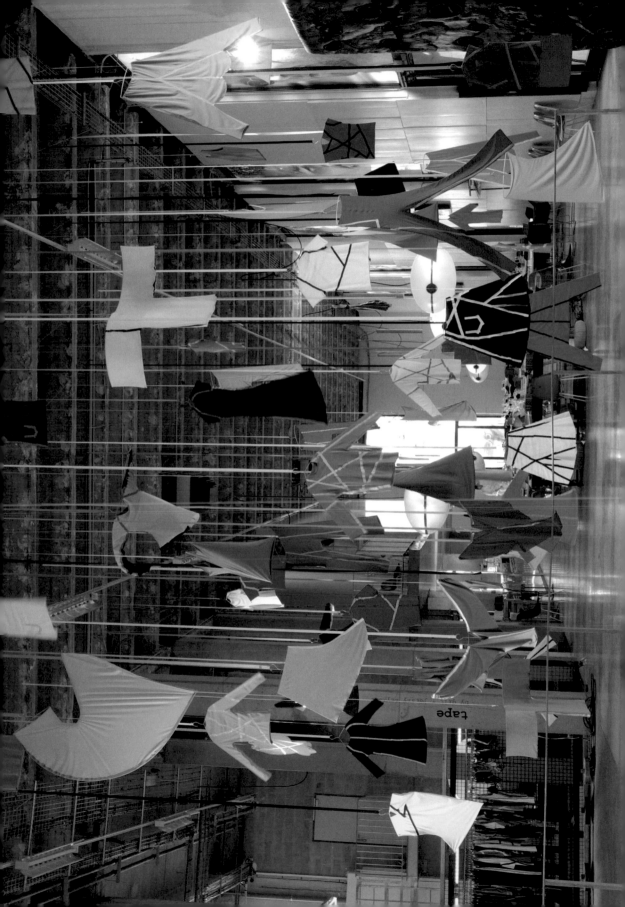

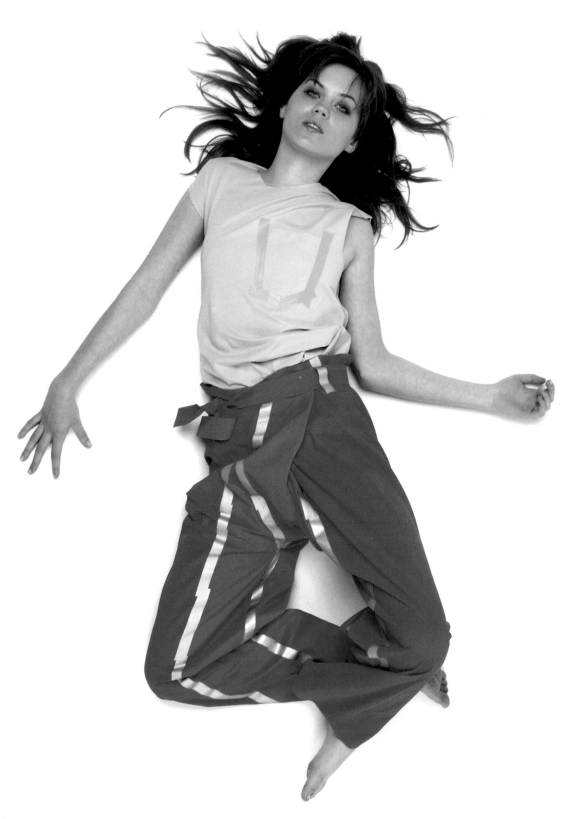

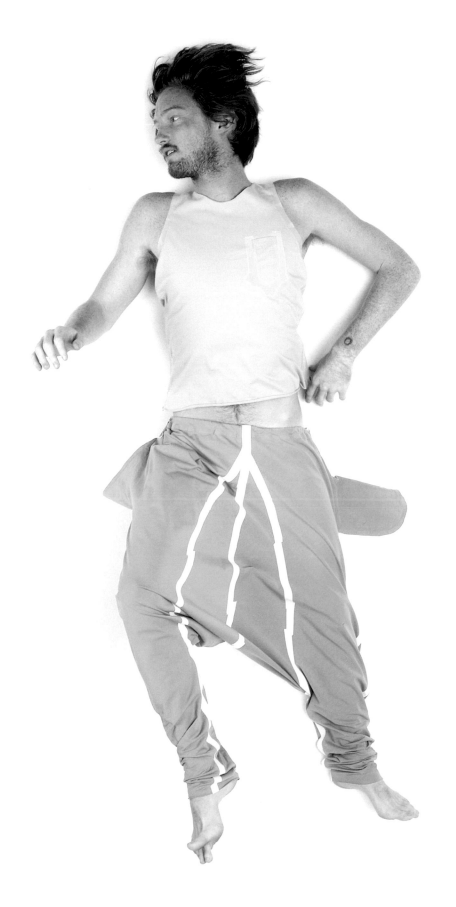

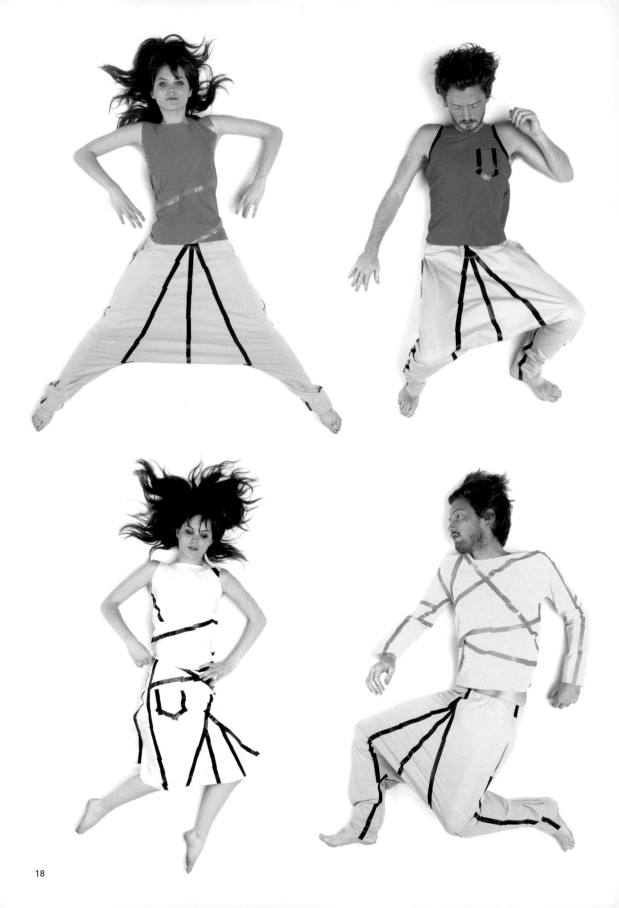

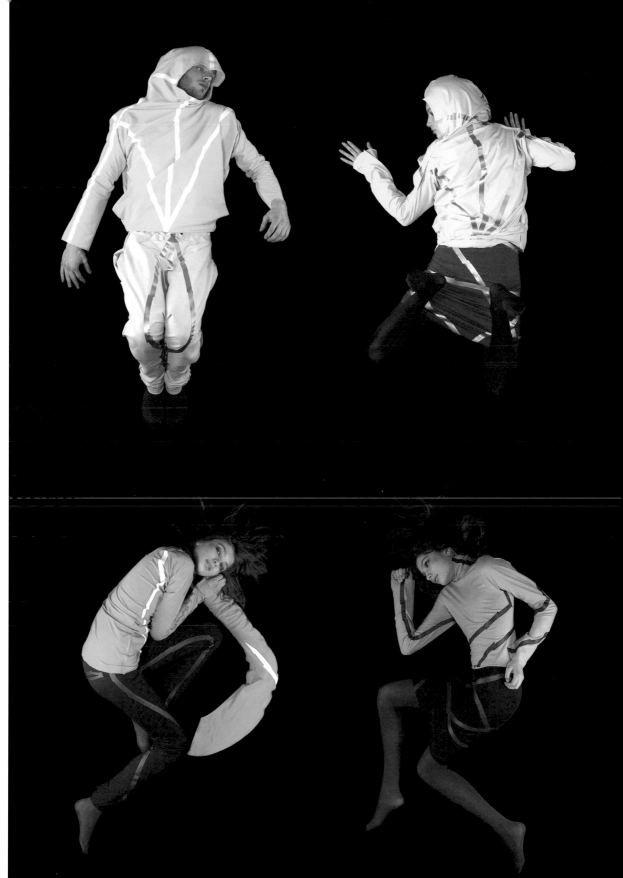

RE-DESIGN

by Pieke Bergmans—Amsterdam [NL] and London [UK]
www.pieke.com

We find viruses in many different places. In fact, every specific subject with a true culture of its own is subdued to the forming of viruses sooner or later. It simply is the nature of nature. It seems that »design« has finally become a virus victim as well. Usually with viruses, when they strike, they strike hard and in many different ways. As we speak, a large variety of viruses attack all existing forms of design. The weak spots of the victim quickly come to light: symmetry, monotony, repetition, mass production and mass distribution. Although most viruses have highly destructive capacities, they often seem to only parasite their subjects or disrupt their common features. Today, the appearance of these viruses seems to have triggered the admiration of many, but the fear of few. That could be the reason why a cure to any of these viruses has not yet been found.

Re-Design is a revision of Jasper Morrison's famous Rosenthal Moon series. In her design Pieke Bergmans goes beyond the original form. The adhesive strips she has applied are not only decoration; they change the design of the well known service. The jury of the Rosenthal Design Award 2004 was so impressed with the work that it recommended the design be put into production as soon as possible.

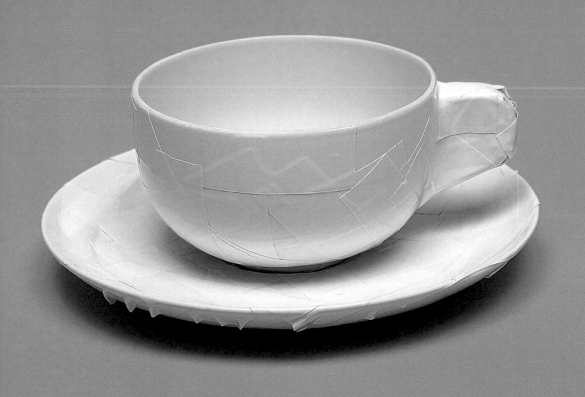

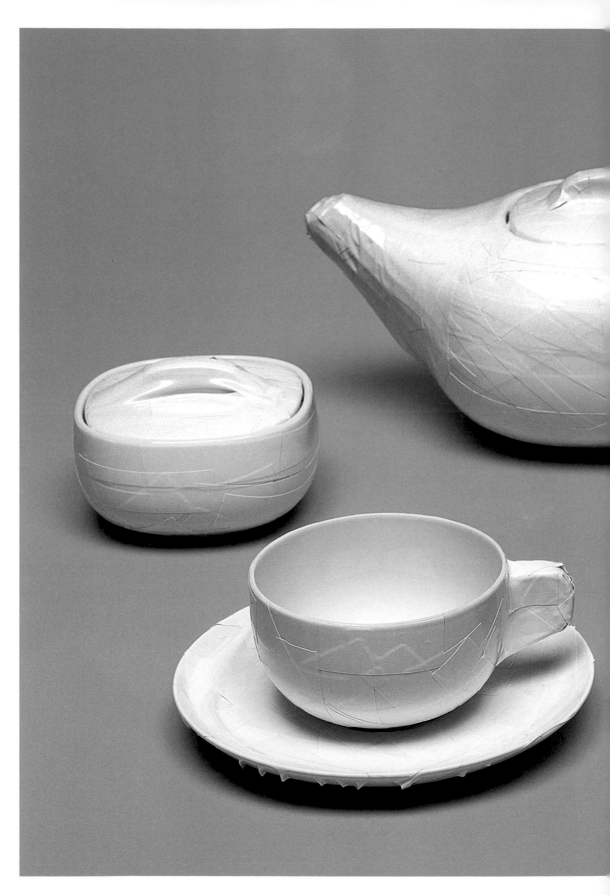

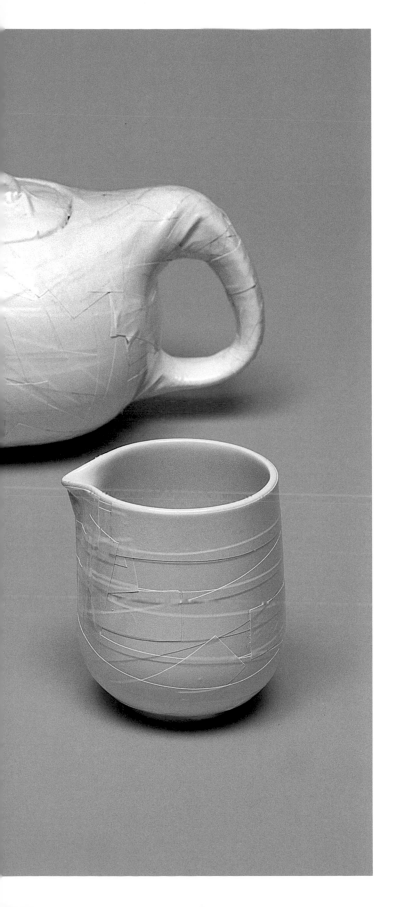

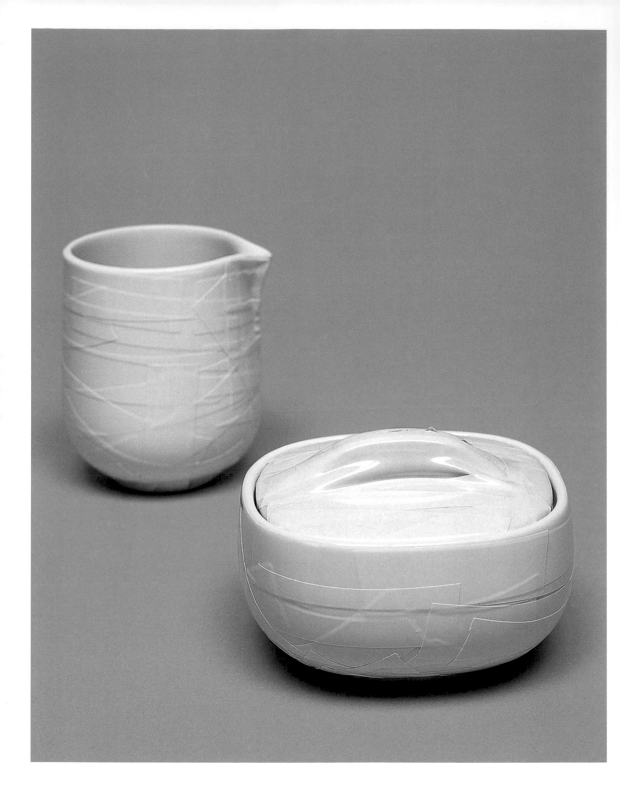

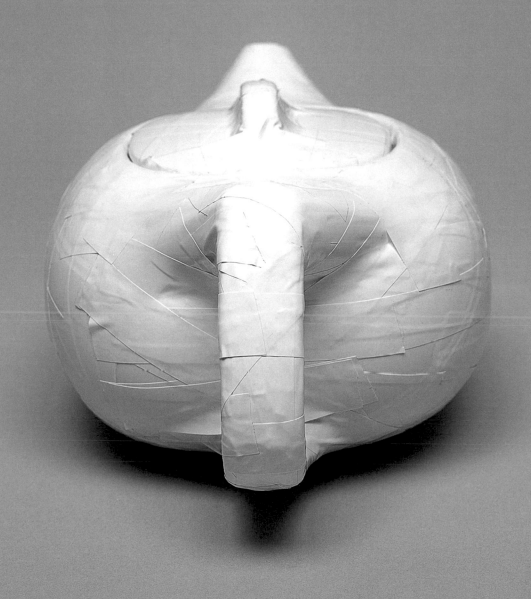

EMPATHY

by Oliver Kartak—Vienna [AT]
www.oliverkartak.com

Cutaneous empathy is the most common naturally occurring type of infection [→95%] and usually occurs after skin contact with contaminated meat, wool, hides, or leather from infected animals. The incubation period ranges from 1 to 12 days. The skin infection begins as a small papule, progresses to a vesicle in 1 to 2 days followed by a necrotic ulcer. The lesion is usually painless, but patients may also have fever, malaise, headaches, and regional lymphadenopathy. Most [about 95%] empathy infections occur when the bacterium enters a cut or abrasion on the skin. Skin infection begins as a raised bump that resembles a spider bite, but [within 1 to 2 days] it develops into a vesicle and then a painless ulcer, usually 1-3 cm in diameter, with a characteristic black necrotic [dying] area in the center. Lymph glands in the adjacent area may swell. About 20% of untreated cases of cutaneous empathy will result in death.

Inhalational empathy is the most lethal form of empathy. Empathy spores must be aerosolized in order to cause inhalational empathy. The number of spores that cause human infection is unknown. The incubation period of inhalational empathy among humans is unclear, but it is reported to range from 1 to 7 days, possibly ranging up to 60 days. It resembles a viral respiratory illness and initial symptoms include sore throat, mild fever, muscle aches and malaise. These symptoms may progress to respiratory failure and shock frequently developing from meningitis.

Gastrointestinal empathy usually follows the consumption of raw or undercooked contaminated meat and has an incubation period of 1 to 7 days. It is associated with severe abdominal distress followed by fever and signs of septicemia [blood poisoning]. The disease can take an oropharyngeal or abdominal form. Involvement of the pharynx is usually characterized by lesions at the base of the tongue, sore throat, dysphagia, fever, and regional lymphadenopathy. Lower bowel inflammation usually causes nausea, loss of appetite, vomiting and fever, followed by abdominal pain, vomiting blood, and bloody diarrhea.

This artwork emerged from and coincided with the WTC tragedy. Oliver Kartak in collaboration with Moritz Friedel created this work in a two day period inspired by anthrax, contamination and virus scares.

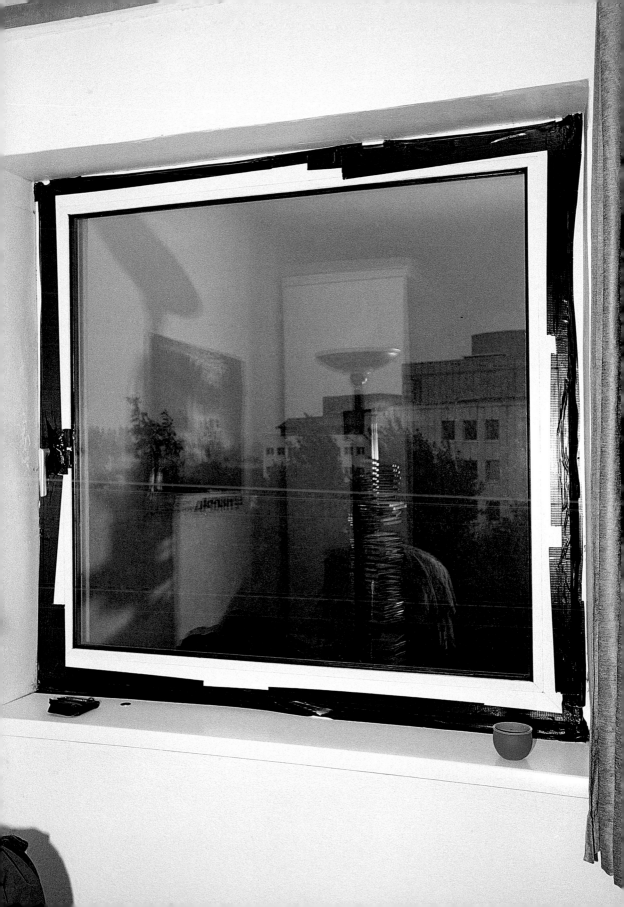

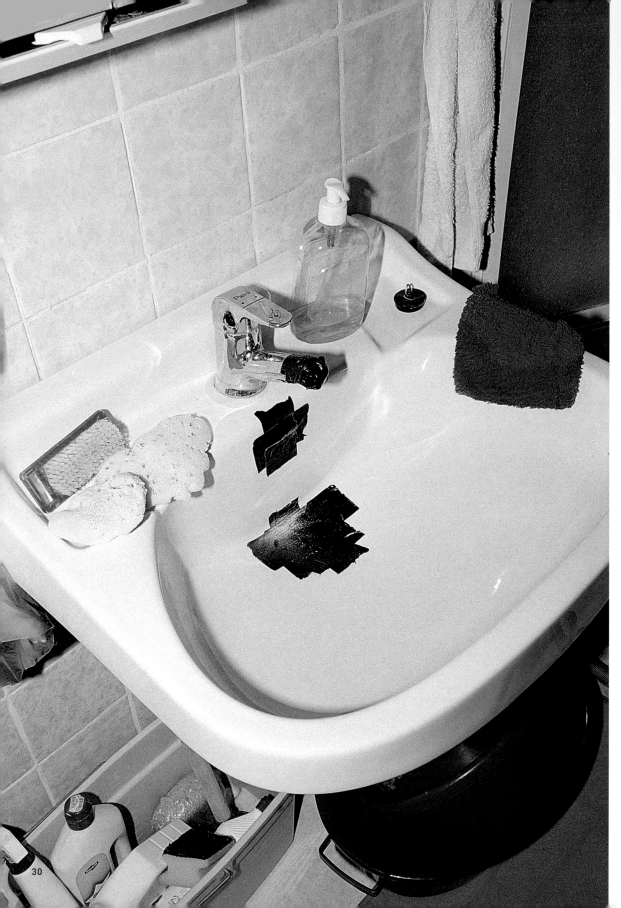

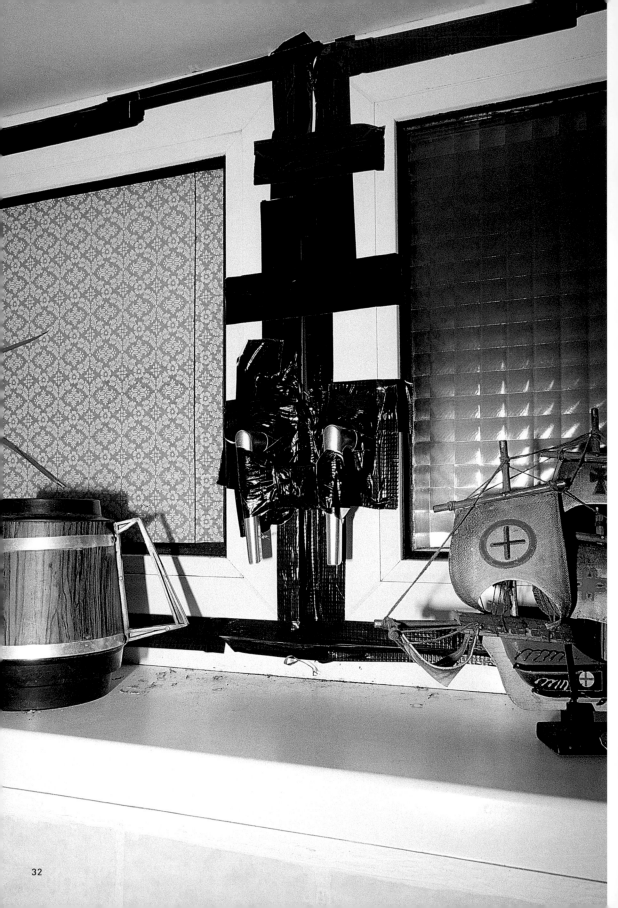

TAPE IT

by Claudia Caviezel—St.Gallen [CH]

—

Swiss textile designer, Claudia Caviezel experiments with adhesive joints on textiles. She tapes shapes, figures and creates installations. While she was working on her diploma as a textile designer, she developed a new technique to make clothes seamless and reversible by using several different adhesive tapes.

Domino effects or chain reactions are her methods. Claudia Caviezel reacts intuitively to what happens, she associates, scans the produced things, and develops. In order to collect materials and impressions she rummages and looks out for objects and techniques which can be used and/or abused. She gets her inspiration from the normal things from her everyday life, and work on them and gives them a new function.

She is additionally working on techniques like transfer printing, silk-screen printing and dying textiles in order to produce her own cloth. The adhesive tape marks her collection »Tape it!«. It appears on accessories as well as in rooms as ornamentical elements.

As she experiments with various materials, methods and techniques, and recycles hand-made and already existing cloths, clothes and other objects, she organises a battle of materials and brings it into a new context. An inspiring collection arises, a pool of ideas with drafts, cloths, pictures, clothes and accessories, presented in their various stages of development.

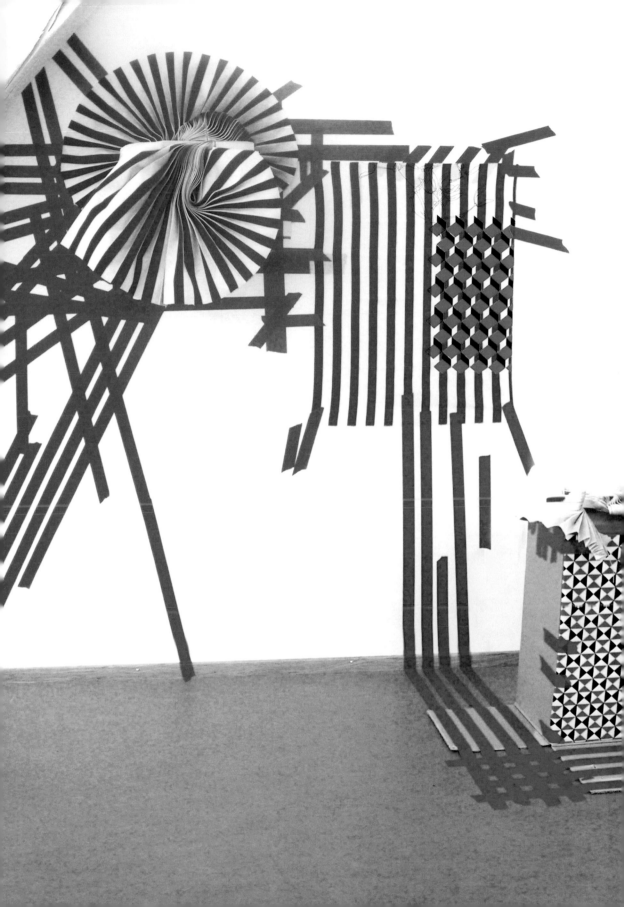

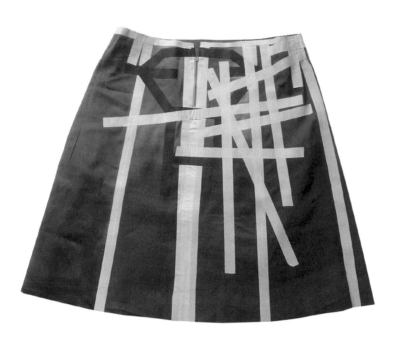

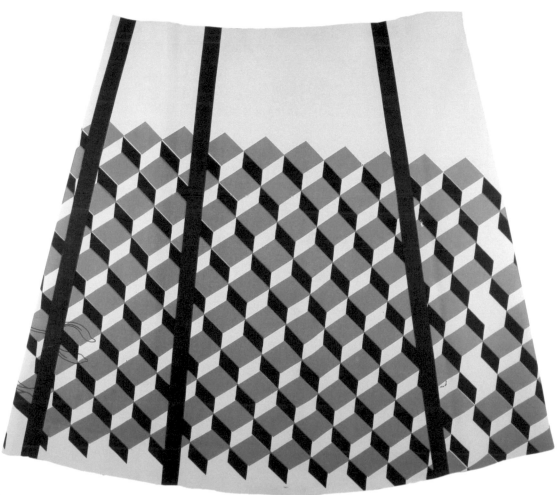

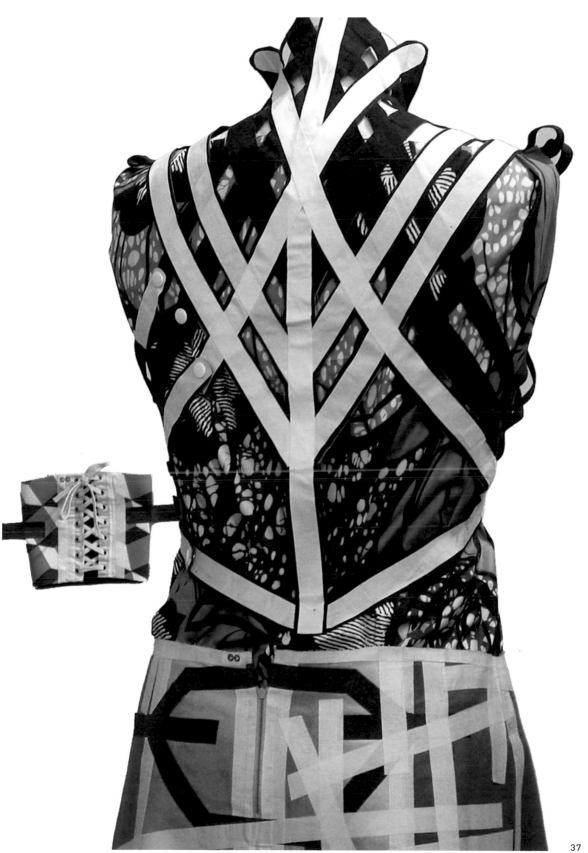

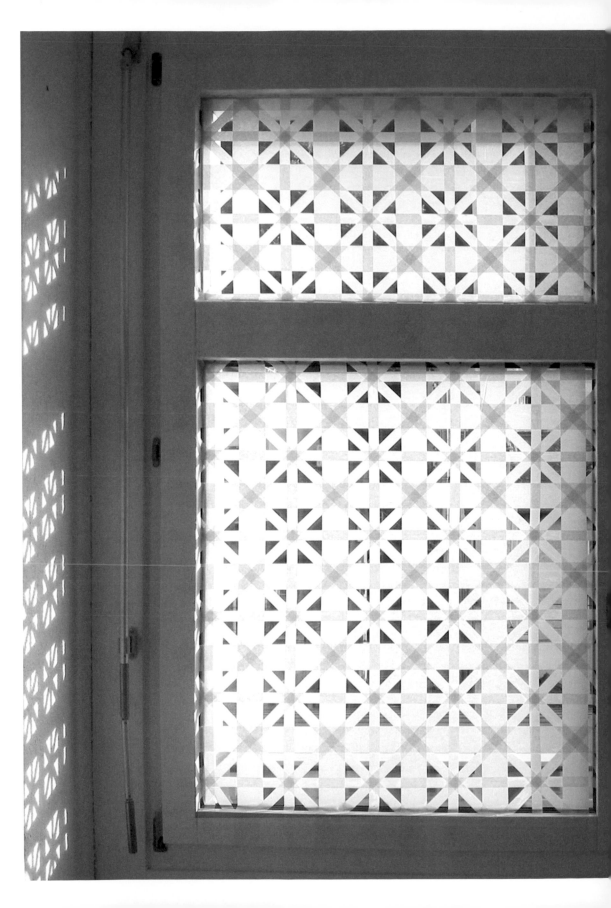

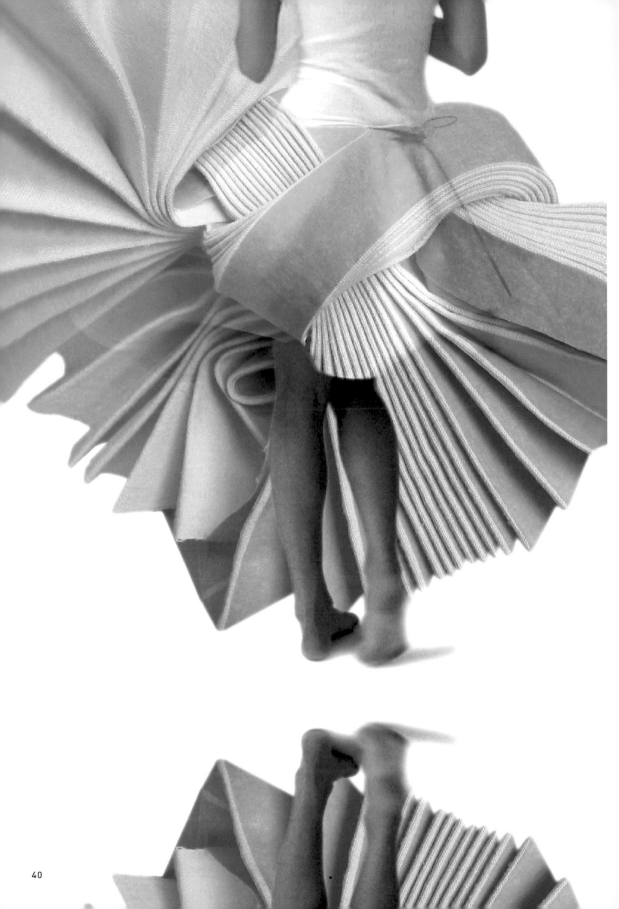

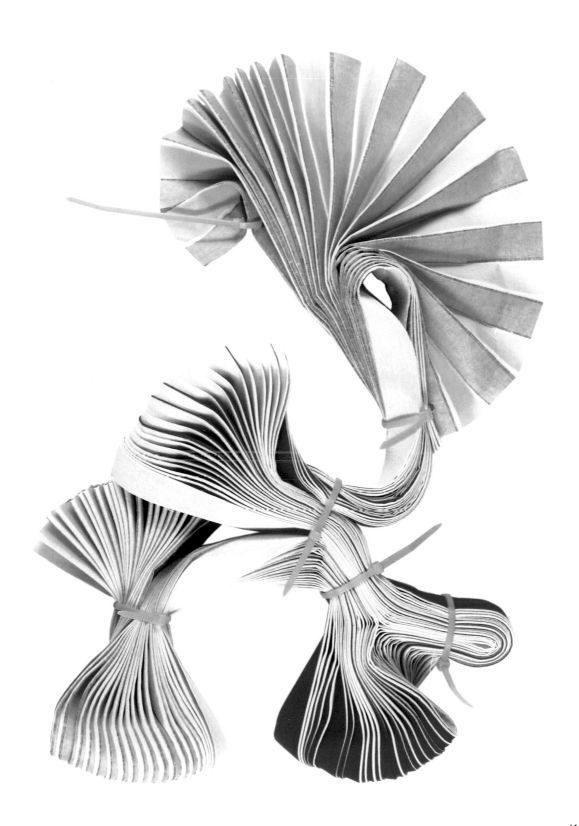

TAPE PAINTINGS

by Valery Koshlyakov—Moscow [RU] and Paris [FR]

———

When I was working with cardboard, I discovered packaging tape. It turned out to be a wonderful means of expression: its aloofness is disciplining and it is limited in the choice of colors. Adhesive tape is well suited for sketching, as an expressive tool for a quick reproduction of an impression. The speed of attaching it, the freshness of its brightness, and the poverty and pureness of colors make it very current and alive.

In 1999 I used tape as an instrument for the »construction of museums« inside museums. I built them using tape on the walls for the project »Applikatives Museum« in Russia (Ivano, Taganrog, Tver) and in Europe (Vienna, Berlin and Ljubljana). Then I realized the project »Paintings in Museums«; I taped famous artists' paintings of artists directly on the walls of the exhibition rooms.

The new project »Art and people–Living with paintings« (Moscow and Paris) embodies democratization – a step towards the consumer, who does not have the possibility to buy fine arts masterpiece. Ideally it should be attached with tape on the walls of the house of the client. The work represents a poster version of the original, but the posters are not produced as a series. With its uniqueness, it is to be seen contrary to the mass products of Andy Warhol.

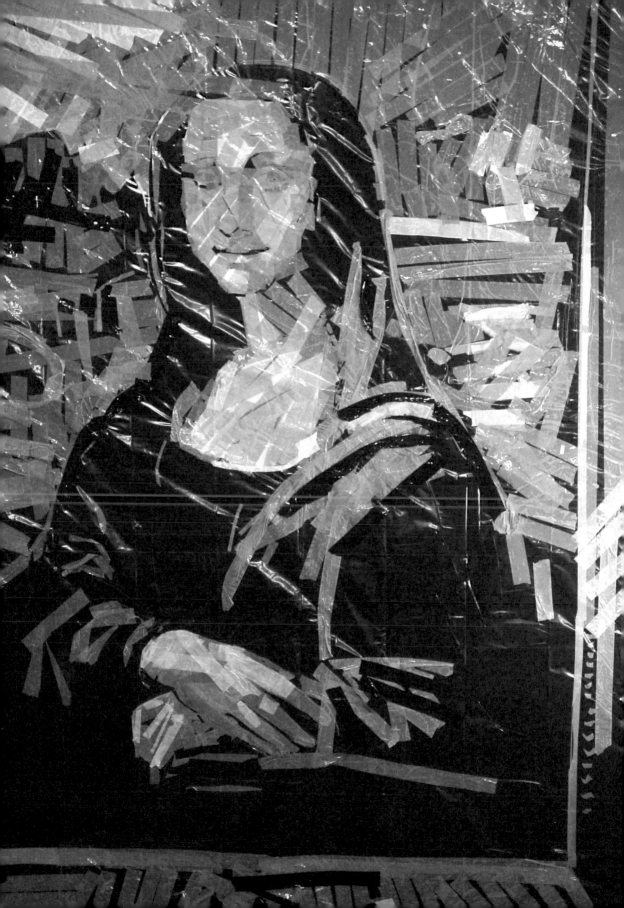

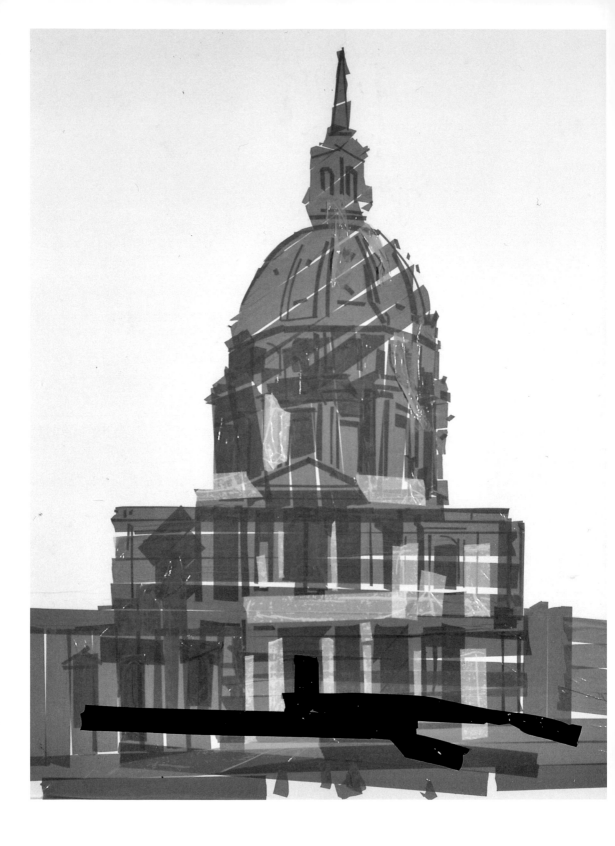

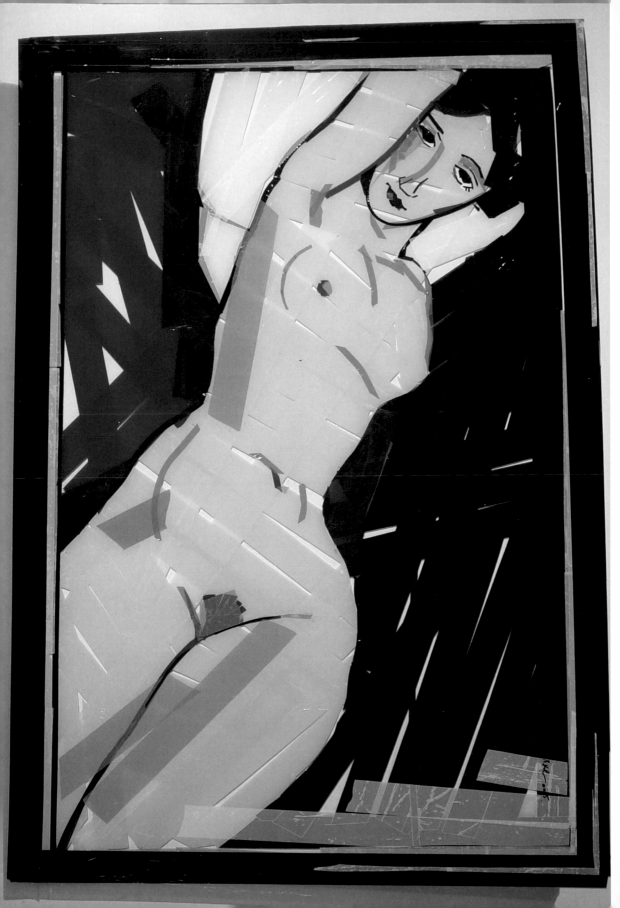

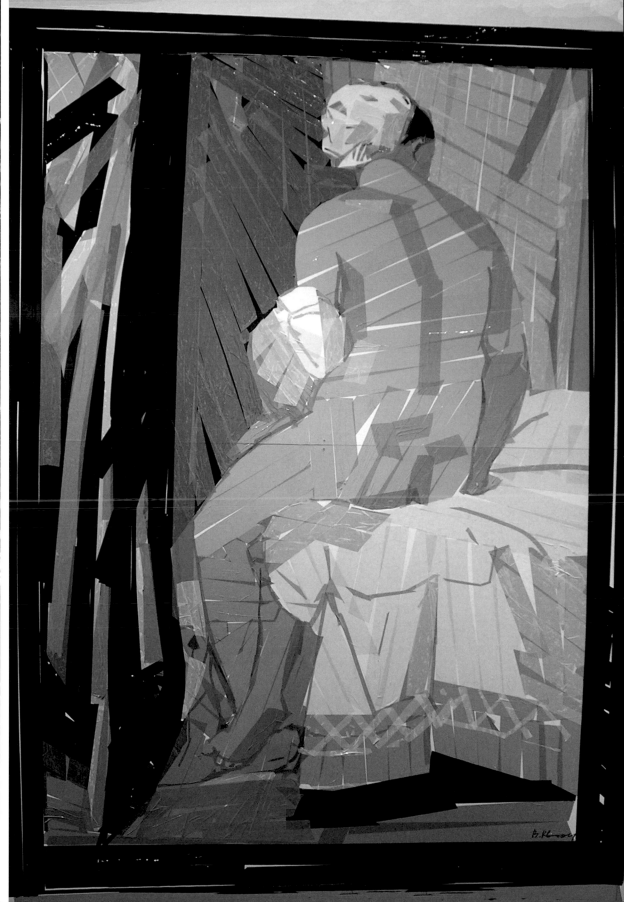

REALITY HACKING NO.055

by Peter Regli—Zurich [CH]
www.realityhacking.com

By taking a perspective usually limited to looking at art in a museum into the everyday world, I interact with existing public situations. The consequences of these encounters are interventions or temporary installations which are often abandoned. In this process the artist subjugates himself to the act of perception by being anonymous.

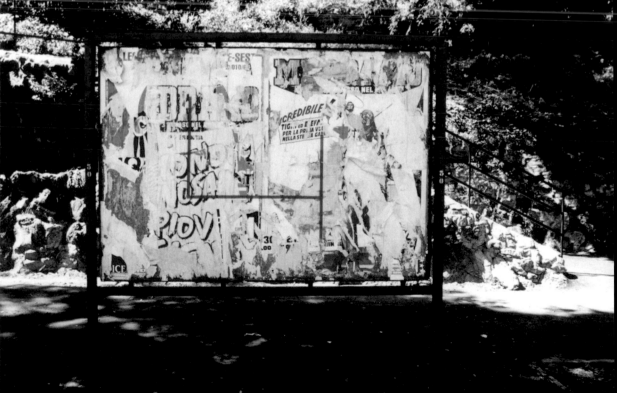

LES URBAINES FESTIVAL

by Fulguro—Lausanne [CH]
www.fulguro.ch

»Les Urbaines 2003 Festival des Jeunes Créations« is a festival held every year in December in Lausanne, Switzerland. It features young creations in various fields like dance, theater, cinema, music, fine arts and performance at ten different artistic spots in the city. It lasts for two days. They have been developing the visual communication of the festival for the past two years and will have the festival again in 2005. The important part of the job was to think of a way of signalising the ten locations and to show that something special was happening there. The scotch tape was a simple and flexible way of marking each place for two days. It did not have to last for long. It only had to be flashy. They edited a special »Les Urbaines« scotch tape and utilized it every wheres on the walls, windows, buses, clothes, etc. to write, decorate, and point. A font was dsigned by simply sticking tape on a wall and digitalizing it. The font tape was used to write in the image of the festival and at the same time to stick the posters on the walls. What Fulguro liked was the rough image it gave to the festival, a place where things are being made, where things are in progress: a building site.

les urbaines

FESTIVAL DES JEUNES CREATIONS

Lausanne
5-6 décembre 2003

le mètr' abstract arsenic circuit ejma loft mu.dac sévelin 36 zinéma

théâtre danse musique cinéma arts plastiques performance

www.urbaines.ch

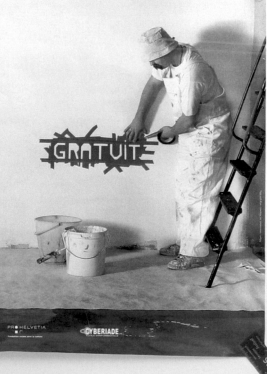

GRATUIT

Lausanne Loterie Romande PRO HELVETIA CYBERIADE

adhésive, une typo en rouleau de 66 m // thin
adhésive, une typo en rouleau de 66 m // medium
adhésive, une typo en rouleau de 66 m // bold
adhésive, une typo en rouleau de 66 m // black

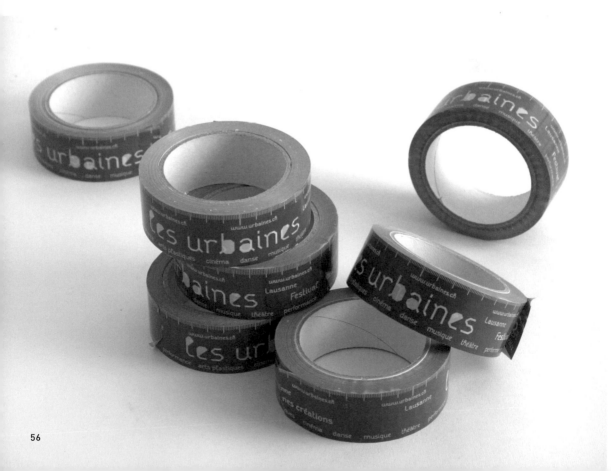

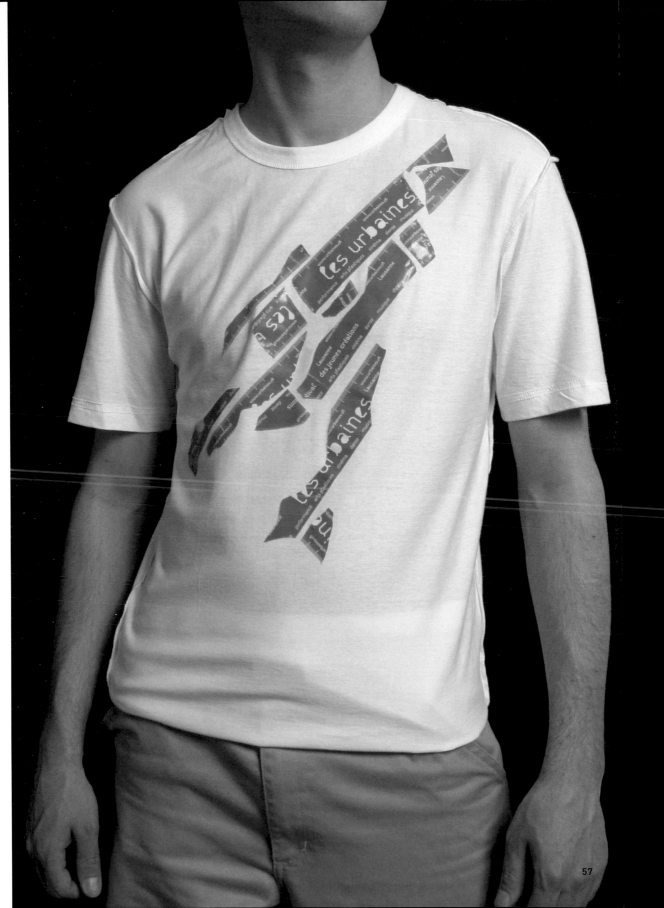

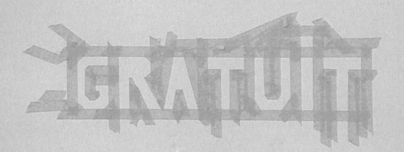

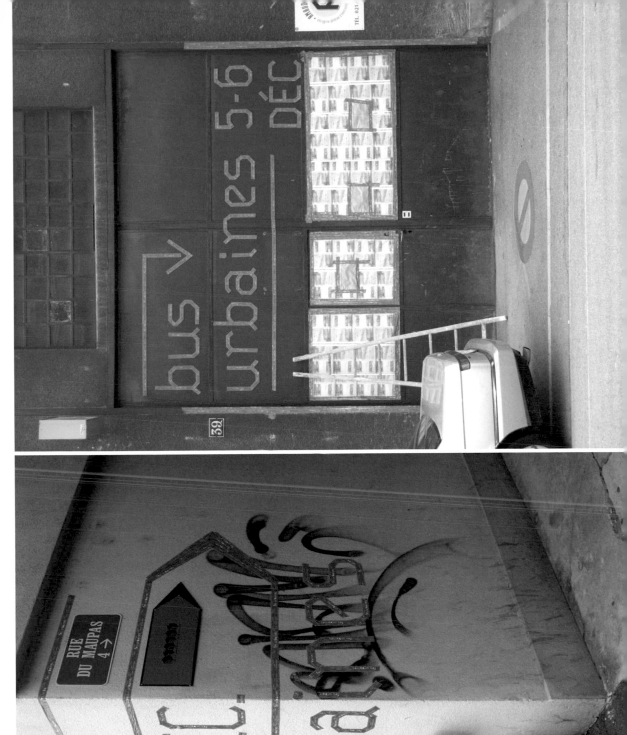

MPR-VZ

by Florian Böhm—Munich [DE] and New York [USA]
www.florianboehm.com

Here's the game. Set a roll of duct tape spinning in mid-air and try to pitch M&Ms through its whirling hole. Succeed, and you eat the candy. Kalpana Chawla, the first Indian woman to fly in space dreamt-up this game aboard the Columbia just days before the Space Shuttle disintegrated 16 minutes shy of landing at Cape Canaveral. Kalpana and the other crew members died as the shuttle came apart passing through 140,000 feet at just under 450 miles an hour.

Kalpana is often recalled as someone who made do with whatever materials were handy. On her first flight aboard the Columbia in 1997, she studied how weightlessness affected various physical processes. Pair Kalpana's Zero-G expertise with the roll of duct tape on board the shuttle, toss in a bag of M&Ms, and her ad-libbed game seems preordained.

You might not expect it, but one of the essential tools for space flight is duct tape; a role is on board every Shuttle mission. For the Apollo 13 crew, duct tape saved their lives after an oxygen tank exploded and they jury-rigged the lithium hydroxide canisters on board to cleanse the spacecraft of carbon dioxide. Ed Smylie, who engineered the improvisation, said his biggest concern was whether the astronauts had duct tape on board to complete the retro-fix. After the rescue, he said: »One thing a Southern boy will never say is 'I don't think duct tape will fix it.'«

Ten days after Kalpana lost her life aboard the Columbia The White House placed the United States on high alert – the second such warning since 9/11 – after the CIA reported that Al-Qaeda would soon strike with chemical or biological weapons. The government advised Americans to assemble emergency supplies, including plastic sheeting and duct tape to improvise a defense against such attacks. Millions cleared store shelves of duct tape. The day the Pressure Sensitive Tape Council, a trade organization, issued a press release announcing that its members had »mobilized to meet the increased demand for duct tape«, Kalpana's role of tape was recovered amongst other shuttle debris near Chireno, Texas.

Compare these three annals of high-profile improvisation with Florian Böhm's photographs of anonymous-make-do-urban-upgrades issued from a society populated by creatures of impulse, and their catch-as-catch-can solutions appear ever more unprivileged. No levelheaded astronauts facing technological failure, no incompetent government strategists reassuring heartland voters with farcical solutions. Böhm's pictures are the witnesses to innovation routinely performed in an extemporaneous self-effacing style. But look more closely and you find that the heart of Böhm's work traces the contours of ingenuity and expediency as the language of human virtue. From here we are not far from Nietzsche »aus der Tugend eine Not machen«, the philosopher's attempt to invert the time-honored adage that would create virtue from necessity.

Text by Ronald Jones, Kosovo and Stockholm

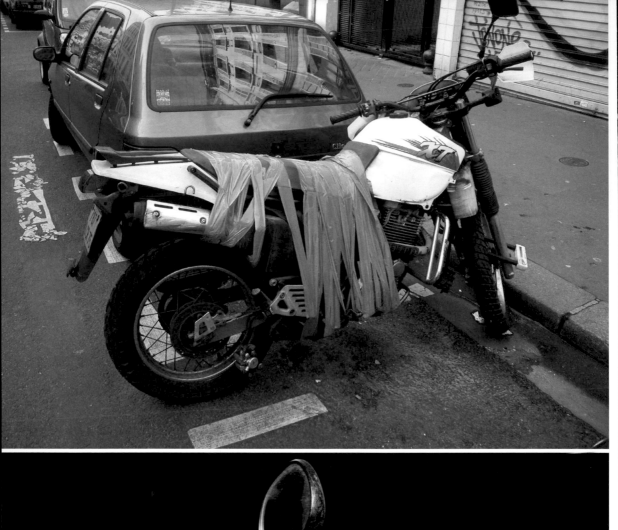

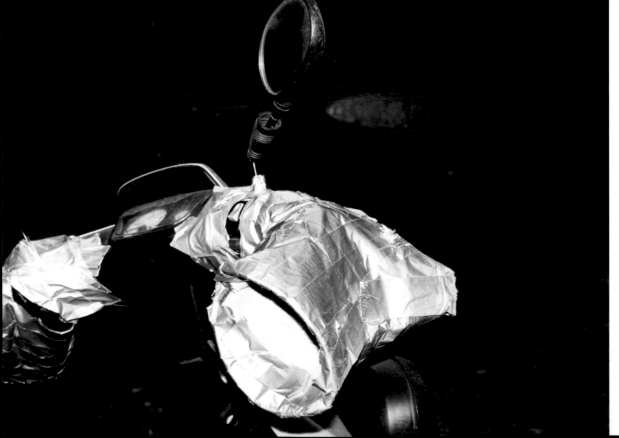

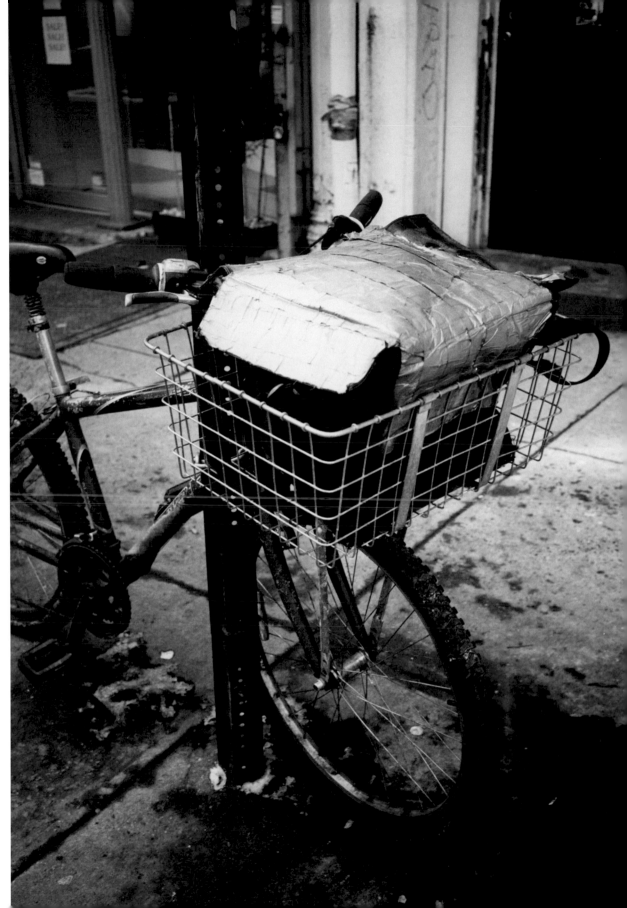

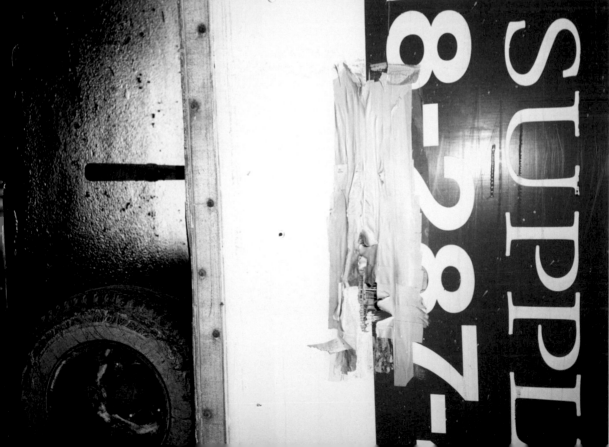

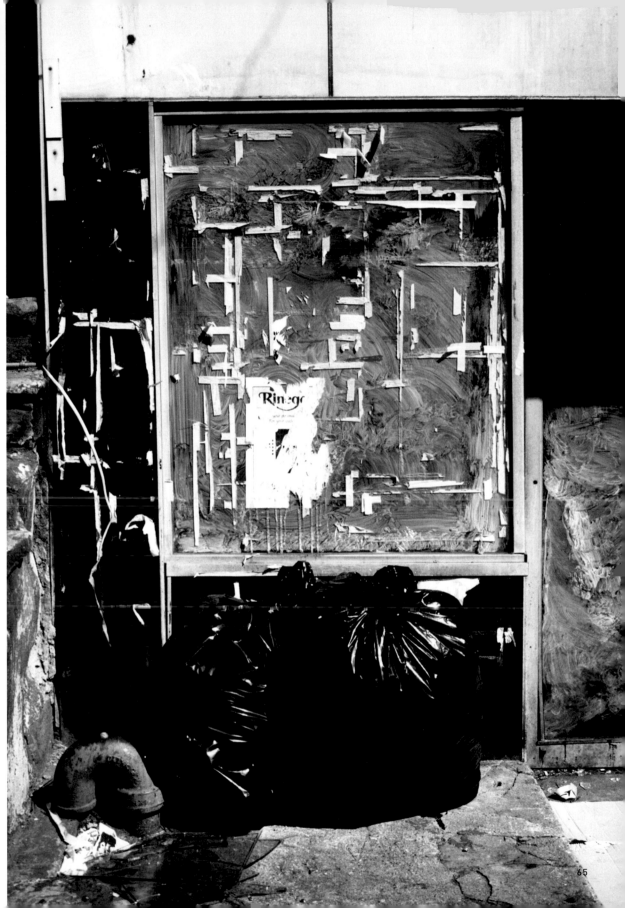

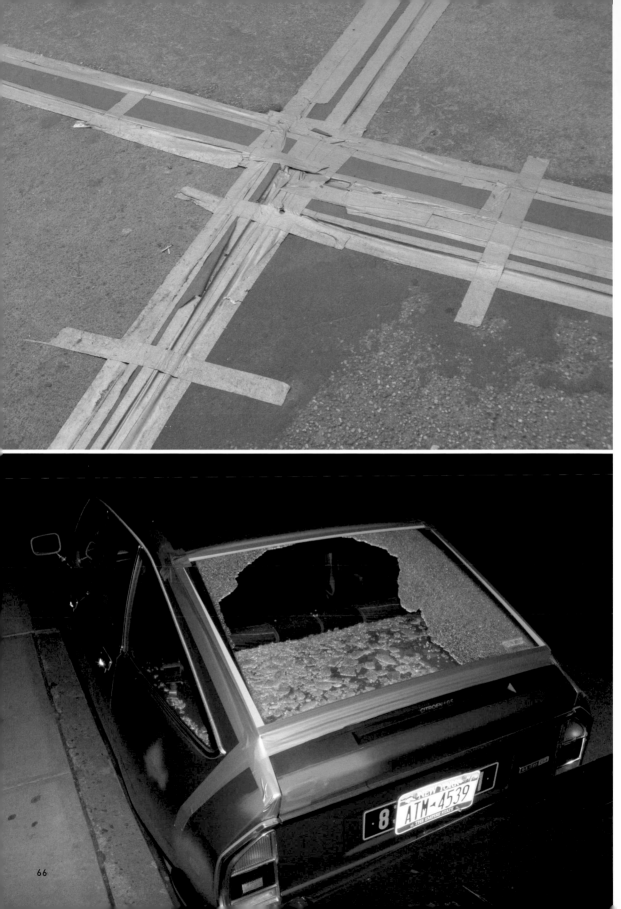

MUSEUM FOR APPLIED ART FRANKFURT: UNDER CONSTRUCTION

by Vier5—Paris [FR]

www.vier5.de

The Museum for Applied Art in Frankfurt changes. Optically. The reason for this is the develop-
ment and introduction of a new graphic appearance. This new coporate design affects all areas
of the museum. A new guidance system will be installed to lead the visitor through the museum,
but also through the other buildings like the administation, the library and the Villa Metzler. New
press-information, posters, catalogues, invitation cards, etc. will be designed.

The development of such a new corporate design, with countless discussions and meetings,
takes time. And so weeks and months pass, with most of the work behind it remaining invisible,
before a new coorporate design is implemented. An interesting question is what really happens
behind the scenes before new colorfull flags and posters are hung up in the end. To explain this
design process and to make the things happening more transparent, the museum has changed
into a »graphic« construction site. The development of the new corporate design is divided into
different steps, whereas the realisation of each individual step can be directly experienced, so
they become really recognisable.

Therefore, all elements no longer needed or those that could not be reused were removed or
masked with packaging tape, so they can be re-labeled with a permanent marker by hand. This
first simplie steps help to review the existing status and to detect what is currently missing or
which information has been lost over the recent years.

In this stage, employees and also visitors can directly influence the design process by contributing
their own ideas, but also by pointing out incomplete information. By this means, a highly efficient
guidance system will be created linking all parts of the museum in a standardised way. By using
very conventional material and tools like tape and permanent markers, lines can instantly be
defined and indicated. Everything can be corrected very easily; just place a new strip of tape,
and it's ready!

For this first step the museum uses the »language of the street« as direct messages on the
wall by marking and disguising everything existing and nonexisiting. Fast and coarse shapes.
Direct letterings. Now this modern way of communication, as seen in our cities for years [e.g.
Graffiti], makes its way into the museum and new forms of applied art enter the well-known
Richard Meier building. The tape strips and taped lines will spread all over the place until they
will be, replaced by the new corporate design, step by step, and become another new exiting
feature of the museum. This surely will contribute to the attractiveness of the building and the
exhibitions.

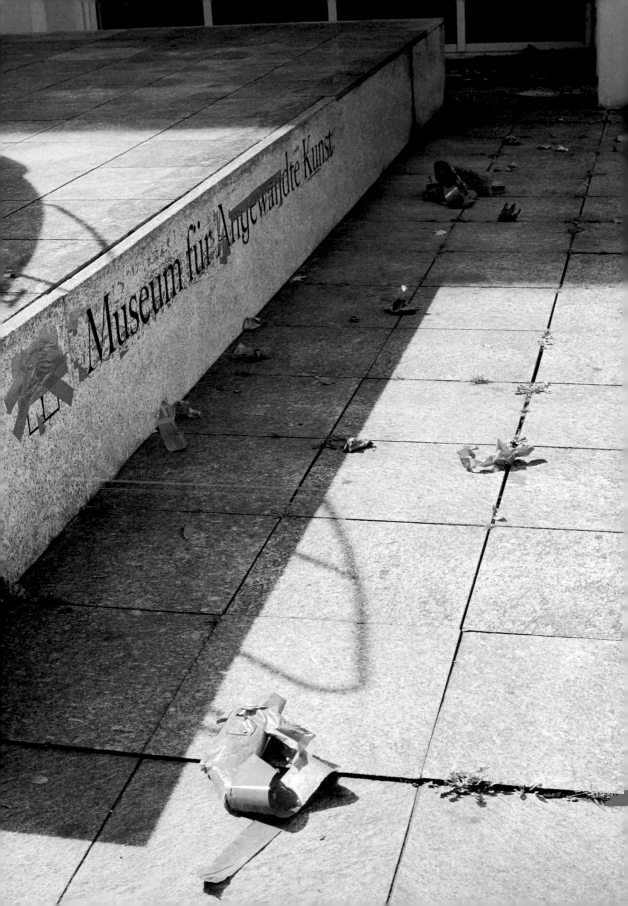

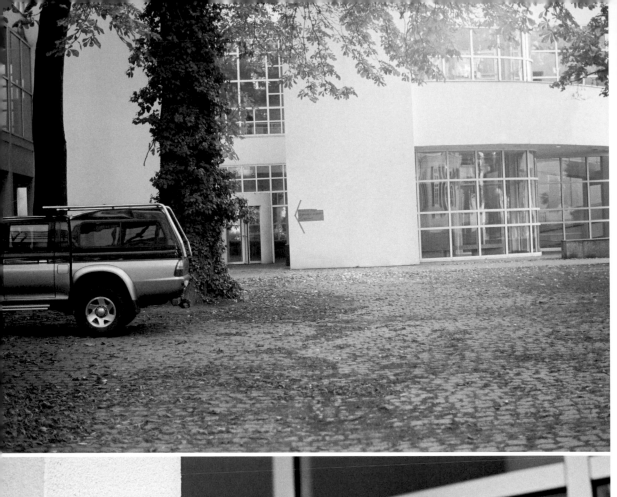

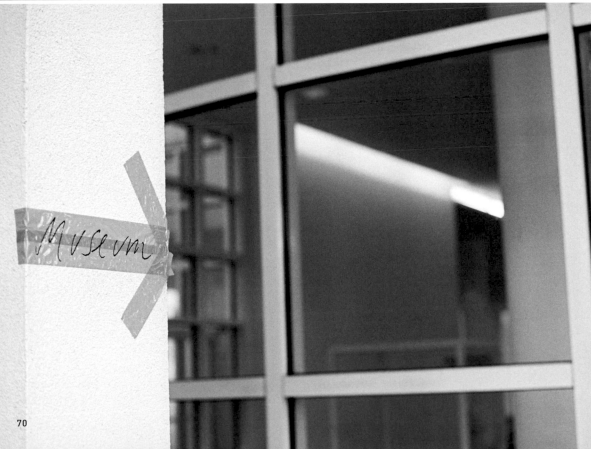

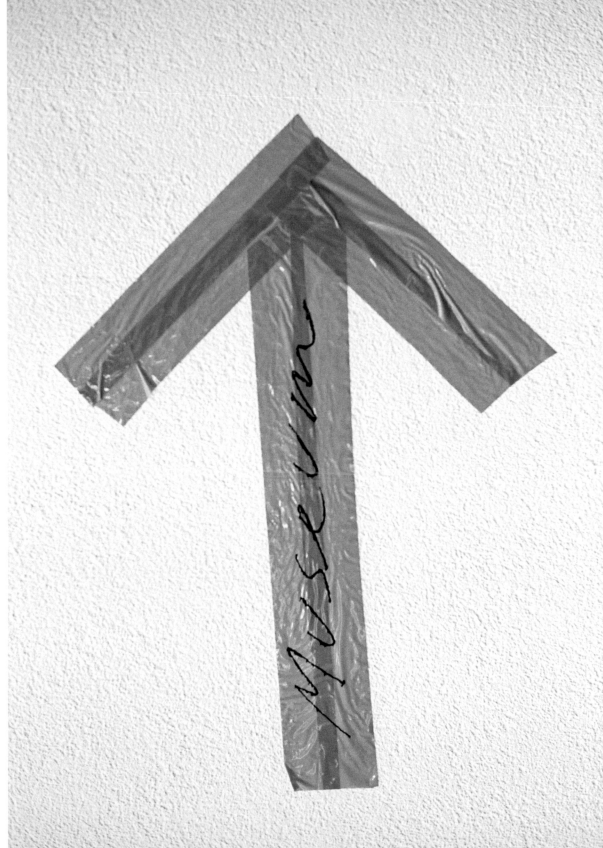

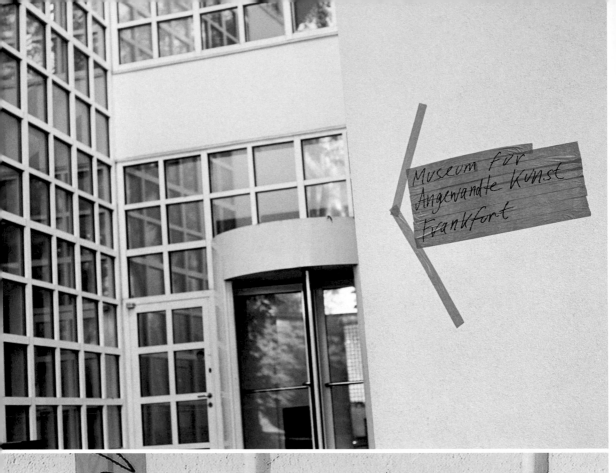

INSTANT LABELLING TAPE

by Random International—Berlin [DE] and London [UK]

www.random-international.com

———

»Instant Labelling Tape« was designed as a simple, customisable, do-it-yourself signage and labelling system. By »blacking out« elements of a 14-segment display font on the tape, you can create your own temporary signs, labels and installations. Label your boxes, put up official-looking signs or even teach your kids how to make letters. You could also re-name your street. All you need is a black permanent marker and a roll of tape [65 m].

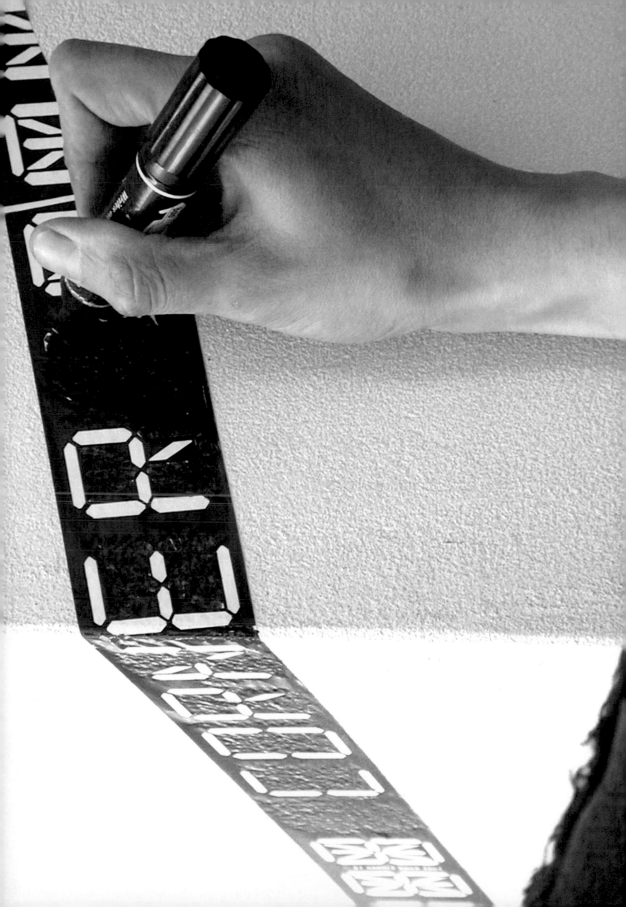

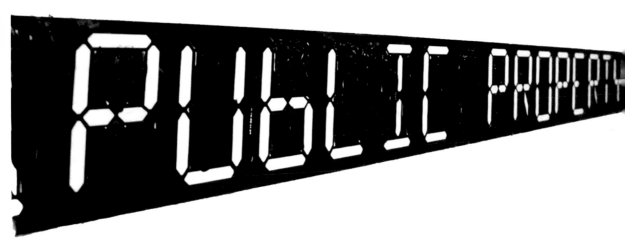

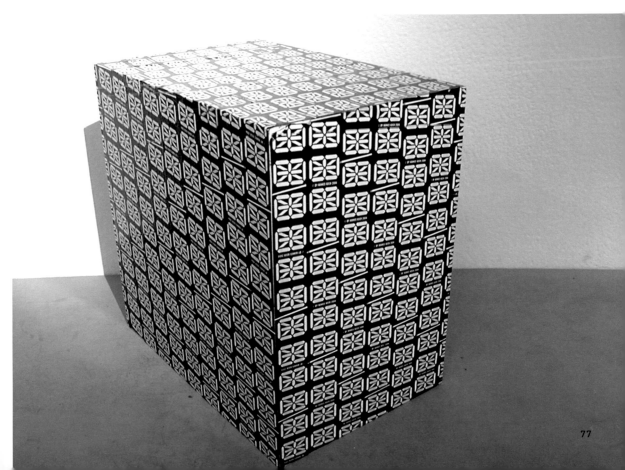

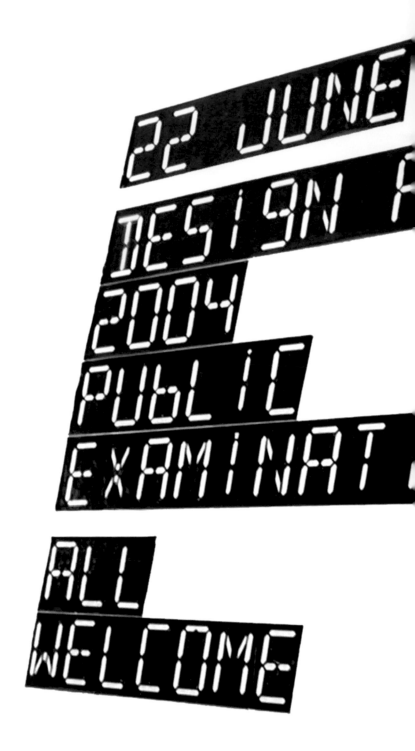

22 JUNE

DESIGN

2004

PUBLIC

EXAMINAT

ALL

WELCOME

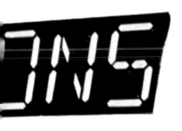

IN ABSTRACT SPACES

by Jim Lambie—Glasgow [UK] and New York [USA]

The dynamic installations of Jim Lambie use coloured adhesive vinyl tape that follow the contours of the rooms. They transform and energize the space by echoing the architectural features of the room and also creating a vortex. Zobop is a further version of his stock-in-trade floor piece, which he first created in 1999. In each gallery space he uses different coloured vinyl tape to define the space and transform the environment.

Lambie places the tape from the outer perimeter where the floor meets the walls towards the centre of the room. His tapes emulate and highlight the particular contours of the gallery producing a rhythm and vibration createing a confusing and disorienting vortex. We are left giddy as if we have been transported along a colour-coded track to some other unimaginable abstract space. Due to the bright psychedelic colours of the glossy tape, the space, saturated in colour, seems to vibrate and pulsate. The colours are reminiscent one of the 1960s Pop and Op Art, as if we have been thrown into a huge abstract painting.

His works provoke categorisation and create debate about what they are: sculpture, architecture or paintings? Therefore they are installations in that they exist only as long as they are installed in these spaces. Percieving the work in real time means that they cannot be looked at like traditional art objects. They have to be experienced in real time and space and are interactive with the viewer. Lambie uses everyday materials, such as vinyl tape, to make something extraordinary happen. The instant impact and appeal of Zobop belies the accurate and labour intensive work. It takes least a two-days to install Lambies' works with the aid of a team of helpers.

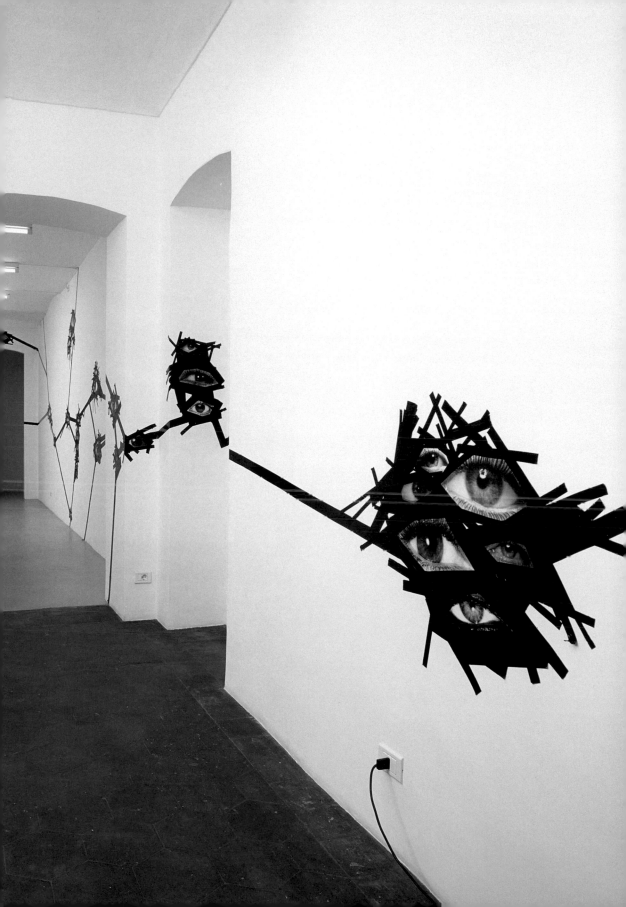

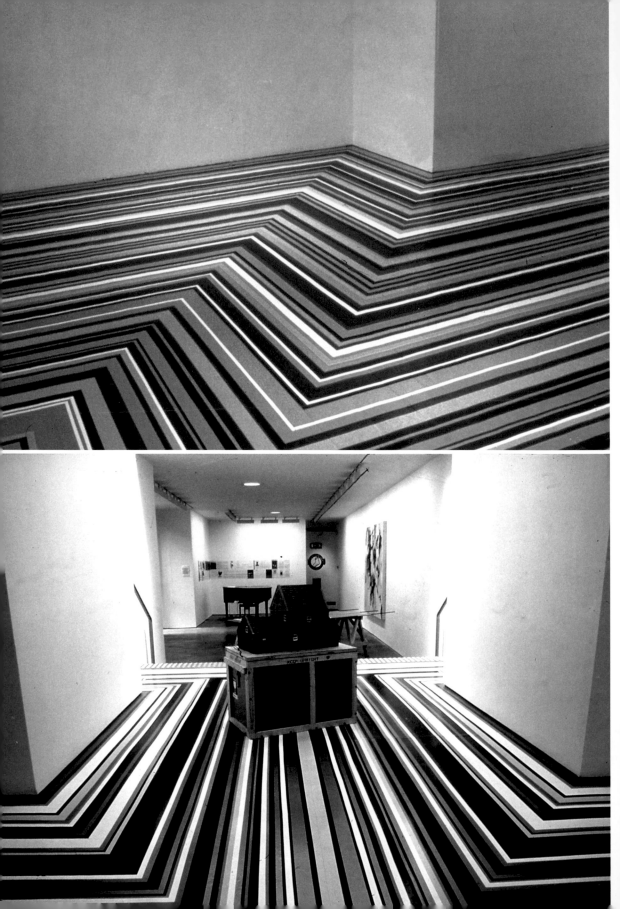

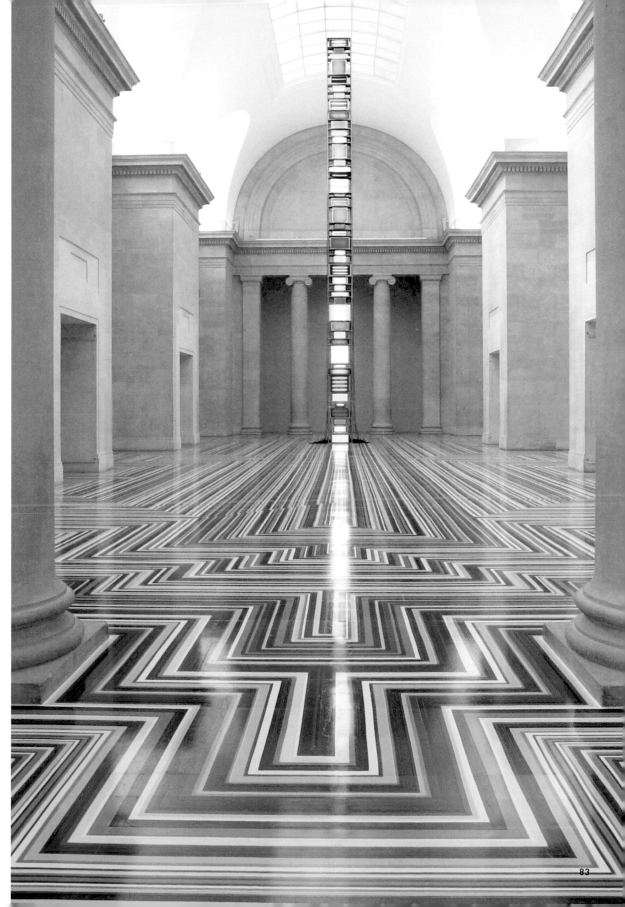

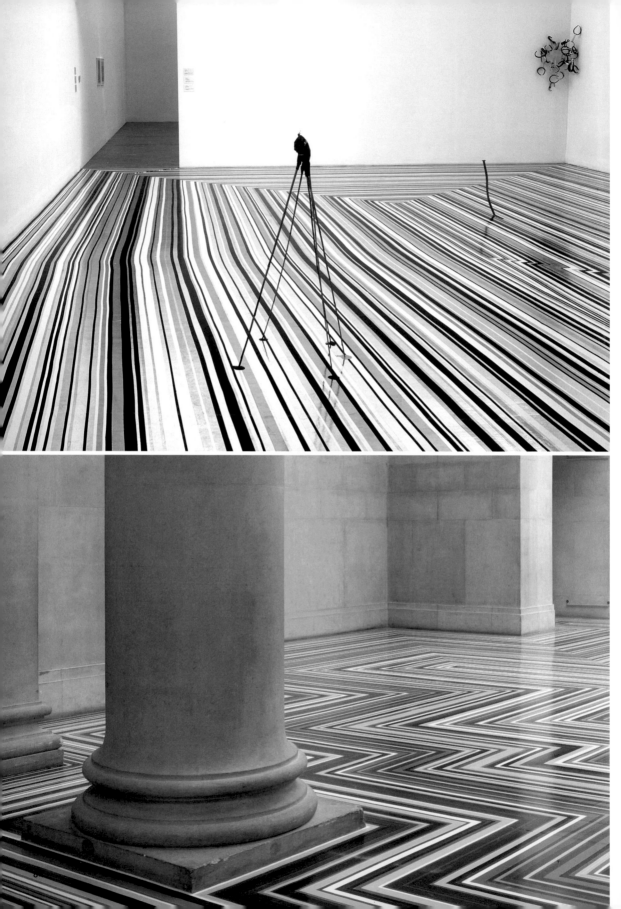

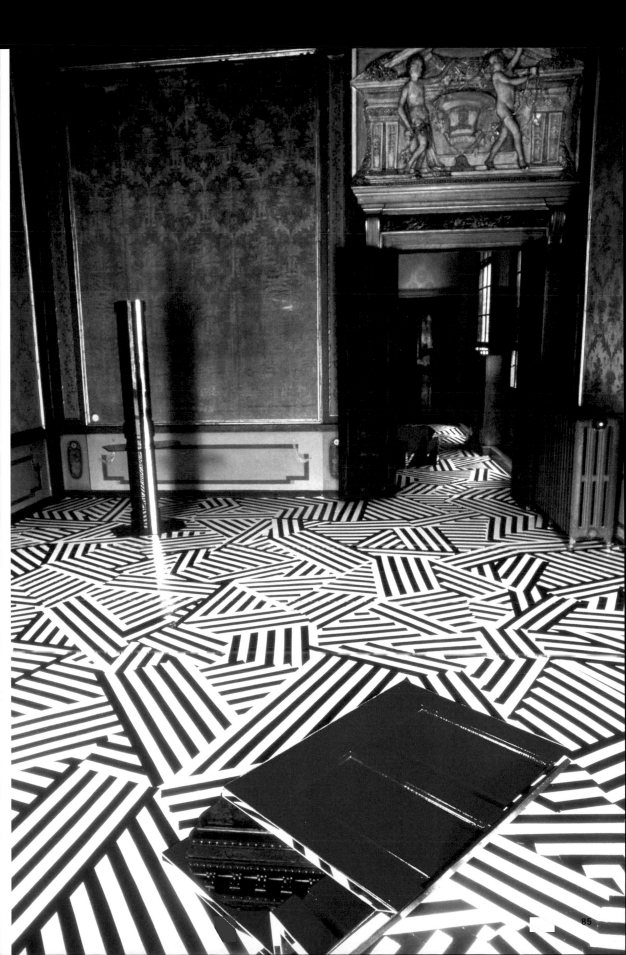

PROJECT 1

by Poni with Special Guest Sylvi Kretzschmar—Brussels [BE]
www.poni.be

The instruments were placed in the middle of the hall. Two men marked the centre area with duct tape. A man quietly took off his clothes and laid down along a ladder on the floor. Little by little people appeared and started making sounds with their body and behaving like animals. The movements transformed. Suddenly it was clear the animals were changing into humans that looked like clichés in the performance of pop stars, in the spirit of spinal tap. A lot of rock and roll started at that point. It looked like masks of black tape were springing out of human faces. Sexual gestures like licking the neck of the guitar. Men running around with their pants down around their ankles, cables tangled around necks and covered heads.

Poni brings molecules, tracing poetical axes by choosing its skeleton, with the vitality and spirit of a larva. An opportunity of becoming one of the many possible iterations of its present identity, an impersonal field where the body and it's music exudes a danced smell, which eructs aesthetic perfumes. It is a ritual field from which images invest as much in extreme pulsing wildness as in the process of introverting. Poni transforms into malleable idiocy from which the identity and scenic argument link more to spontaneous decisions than to representation. Sometimes, Poni transforms in collective idiocies from which the identity and scenic argument link more to transverse of states than the criticism of the subject. One and the other are woven together, transparent of music, in dialog at their own pace on the evident necessity of metaphors and cycles. From yourself to yourself there is the other. Poni presents itself as a village, as a dance, as a couple, in concert, as a concert, as objects, as actions, as a montage, as deconstruction, as binding, as a trance, and more to come.

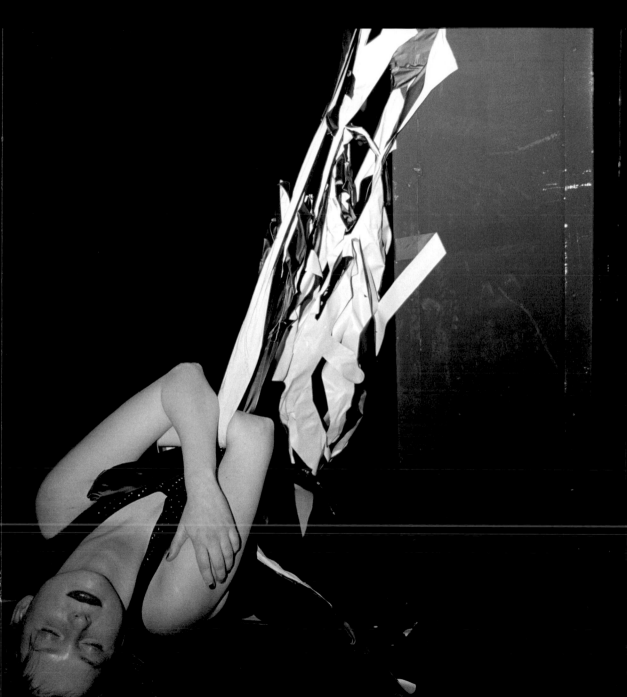

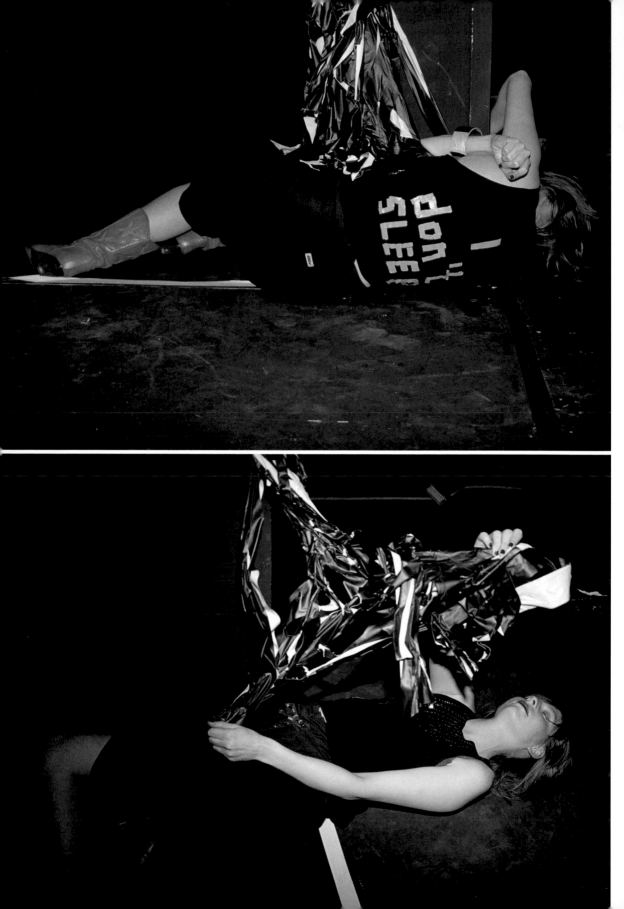

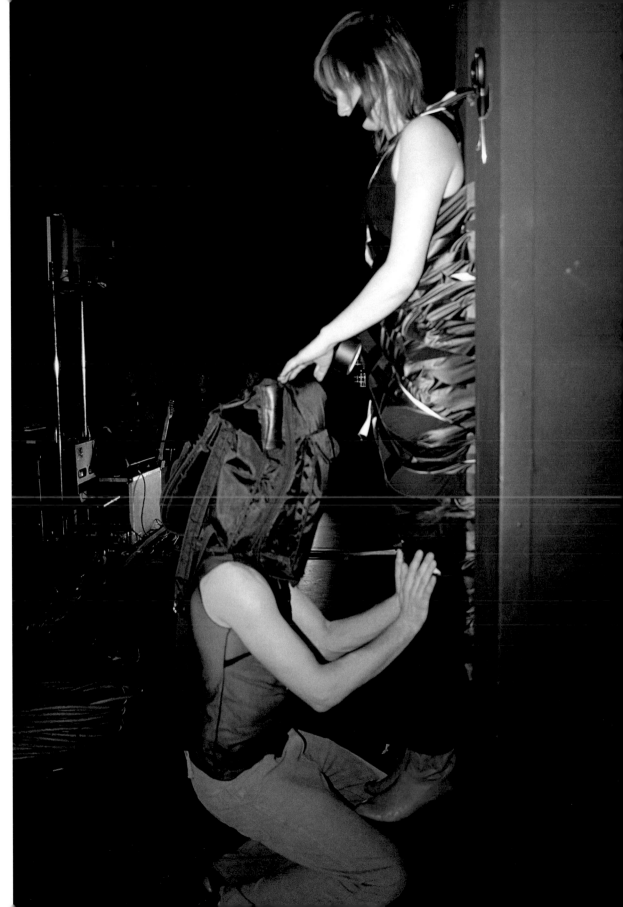

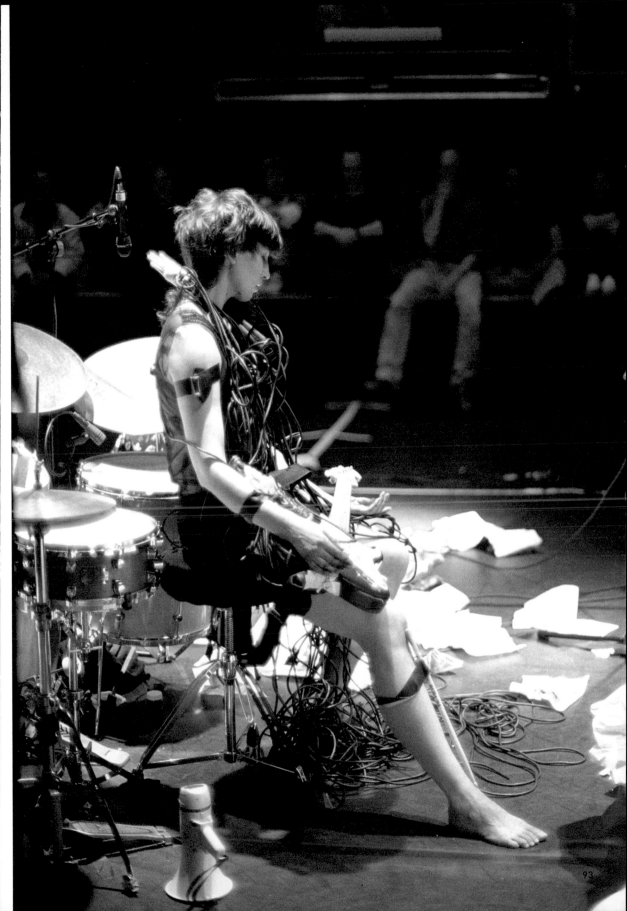

PLANT TAPE

by Chris Kabel — Rotterdam [NL]

www.chriskabel.com

The seeds for plant tape were conceived for an exhibition in Tokyo, 2002 about re-valued waste objects and cheap materials. They were planted in fertilised soil questioning the beauty of refuse and makeshift solutions and watered by the tears formed by the ugliness that surrounds us. Then suddenly, out of a big heap of refuse, this roll of tape started to unroll, sticking on the walls of the exhibition space, covering everything that came in its way with a lush green foliage with the branches and leaves reaching for the artificial light. In the end, this artificial ivy covered the whole space and created a kind of castle for a sleeping beauty. This tape is a five-centimetre wide and fifty-metre long band of green plastic with branches and twigs cut out by laser–oz water-beam. The left over space form leaves that can be stuck around the twigs and branches so that you can create wall-climbers indoors and not worry about pruning or watering

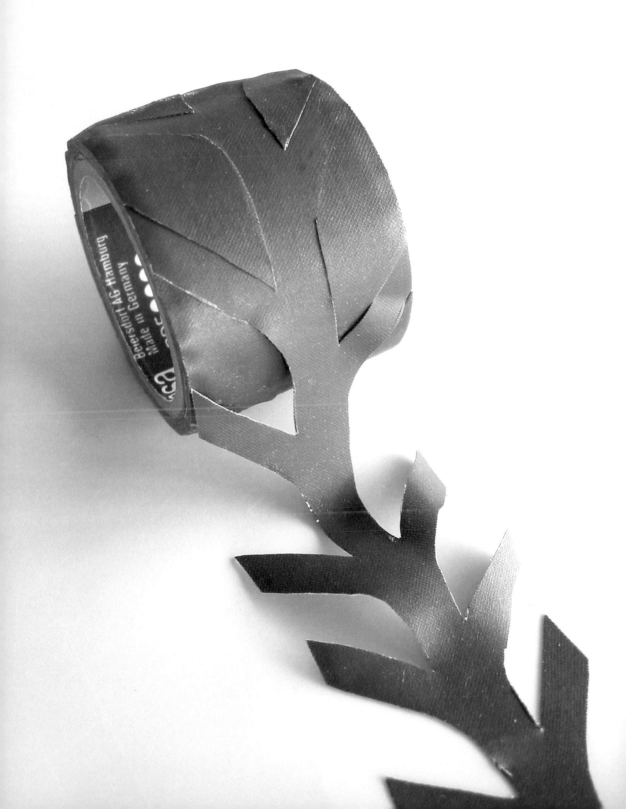

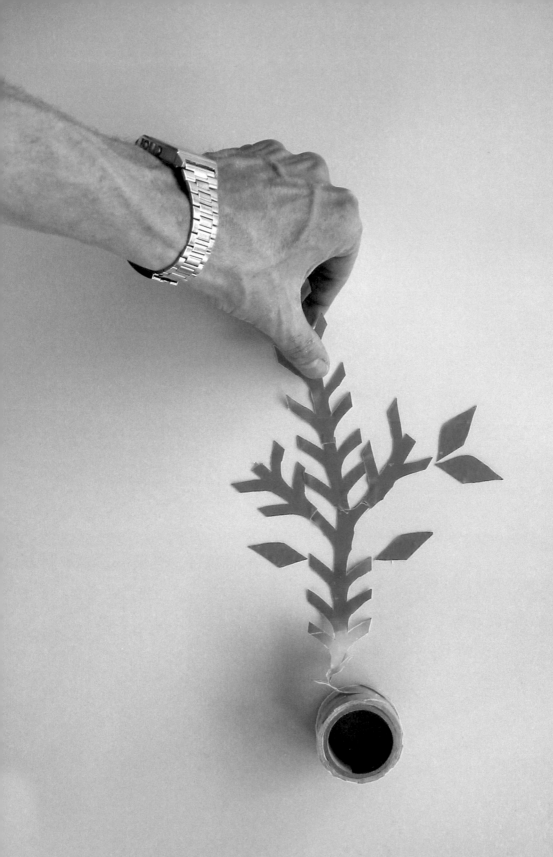

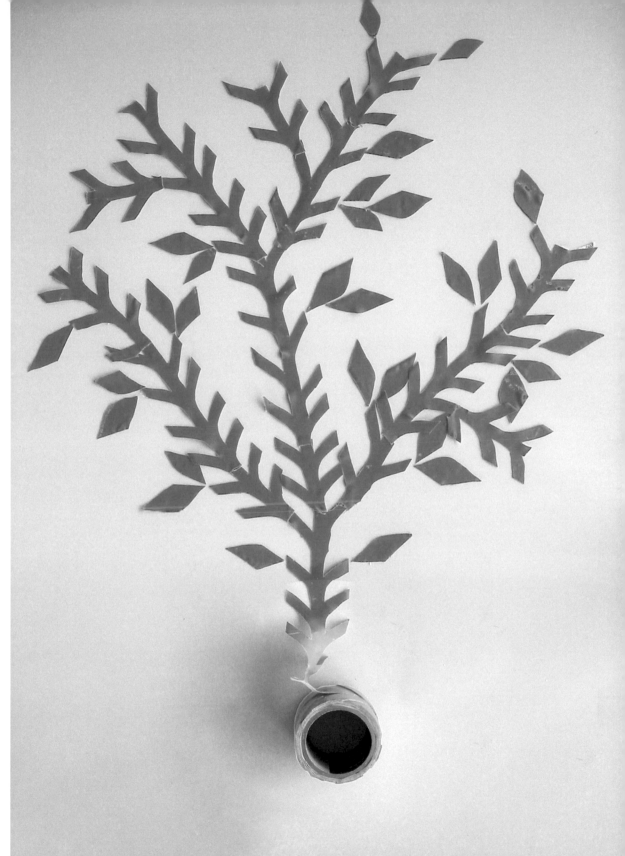

ABOUT THE MATERIAL OF A LOVER

by Beat Zoderer—Wettingen [CH] and Genoa [I]

———

Materials have changed and so have its aesthetic conditions. However, the methodology has remained permanent and it is one of an inconvincible. By calling a spade a spade, the effects of faith and devoutness are displayed. A hole-puncher is used for punching holes, adhesive tape for fastening.

Anybody who is astonished with artists using media for their productions that were originally invented out of the passionate affection for bureaucracy, used again with the same passionate methodology required by the system maximisation of the filing strategy but under different aspects, has never considered the practice of communication and the precise elegance of services performed by bureaucratic media. Their search is sometimes too extensive or they define art in a way that the materiality and aesthetics have to be congruent. This it not Zoderer's theme. On the contrary, he is interested in combining the aesthetics of constructive art founded in the universality with the communal properties of trivial objects, deducing his own stories from this. The expression «Le roi est mort - vive le roi» secures the constructive continuity, but maybe under different omens. Deceit and disappointment are integrated. The appearance of a work from afar is not the one released close at hand; the level in between has changed. Within their classical, vertical and horizontal orders, the protagonists live their own anarchic lives.

Even if one half can survive without the other, they are still two sides of a single story. The top and the bottom, the sublime and the trivial. Trapped in a never-ending changing dialogue, everyone for themselves, stick to the main characteristics of their role play: matter and materiality here, composition and ordered patterns there. Their structural connection can be compared to a joke; only the one who knows the beginning and the end gets the punch line. In subversive cooperation they undergo the rules of «good form», demonstrate material authenticity where it should not be according to the rules of art, use the serviceability against the grain and do not hesitate to transfer the flesh-coloured flexible elastic undergarment band into the elegant straight line of the vertical. The world of objects has (rightly) been banned from the compositions of the classical modernity. Here it re-enters as a fractious team-player and double-player of a hierarchical structured order. It insists on its own rules and asserts its communal existence in the coordinated system of pure form.

When Zoderer's «plunders» shop displays the most trivial items of day-to-day use, it might just be a reversal of the utopian moral concepts. Since then, «beauty» has only rarely entered department stores. But why should the department stores not find their way to «beauty»?

The here and now always happens in the picture.

Extract from a text by Elisabeth Grossmann, published in the »Lagerware IX.95« catalogue, Kunsthaus Aarau [CH]

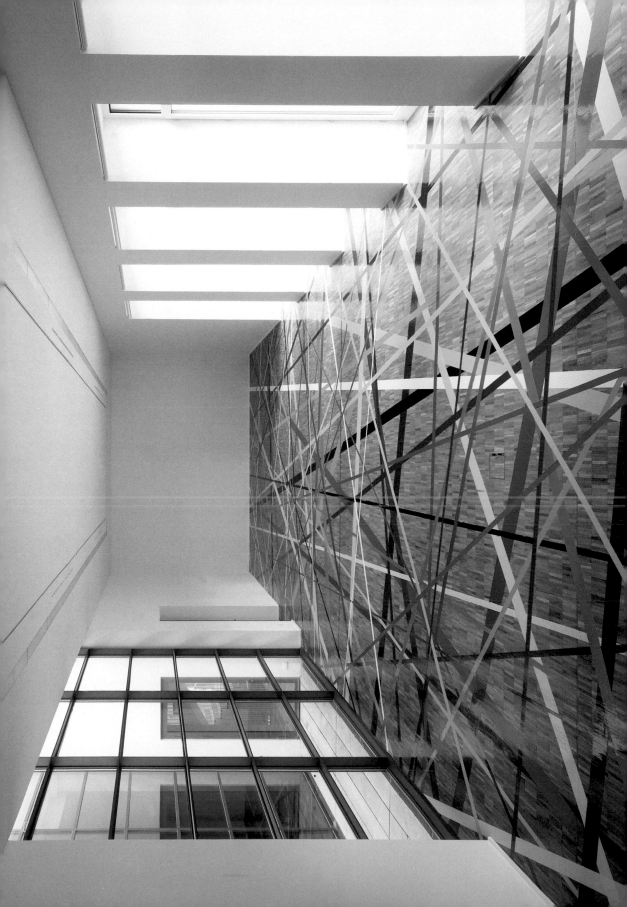

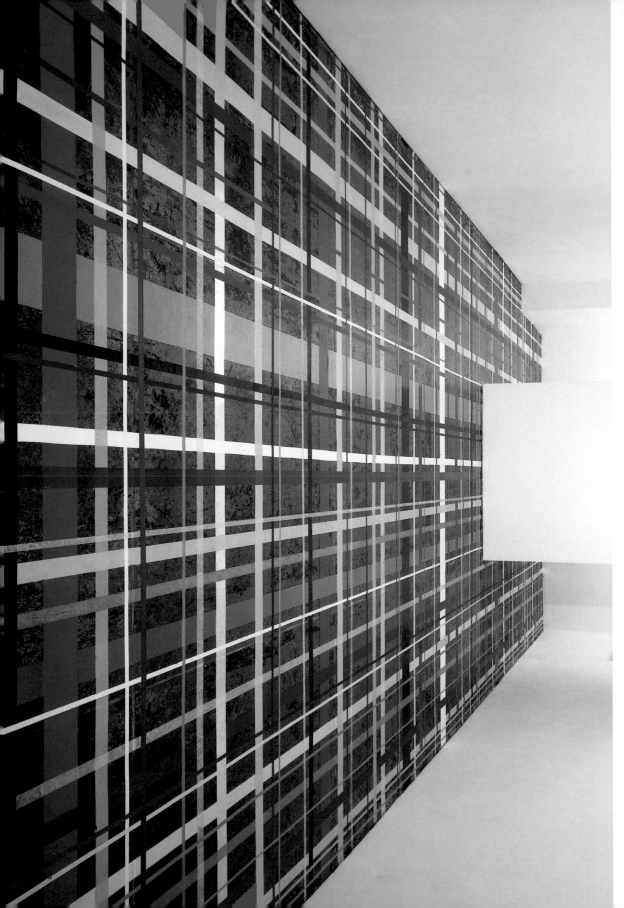

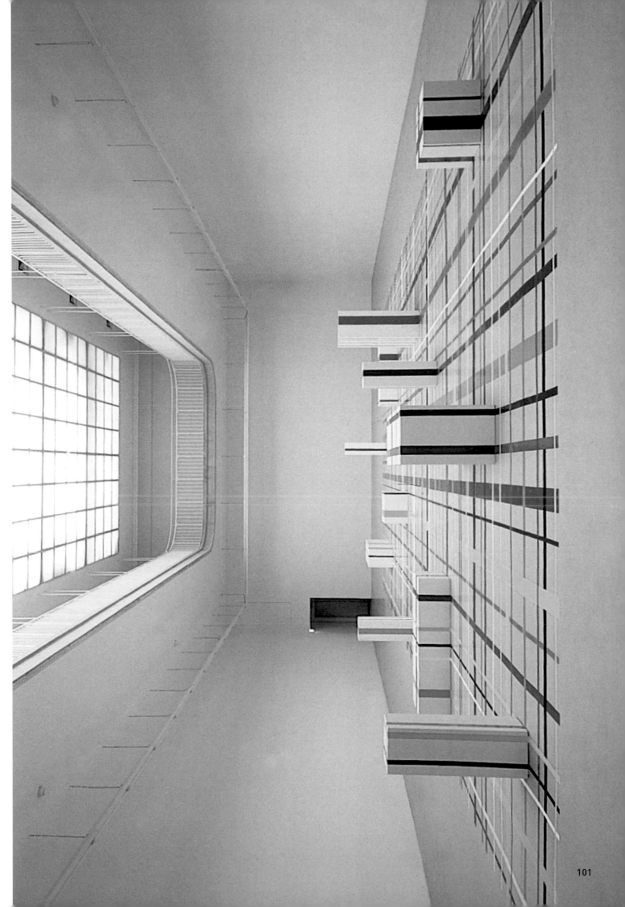

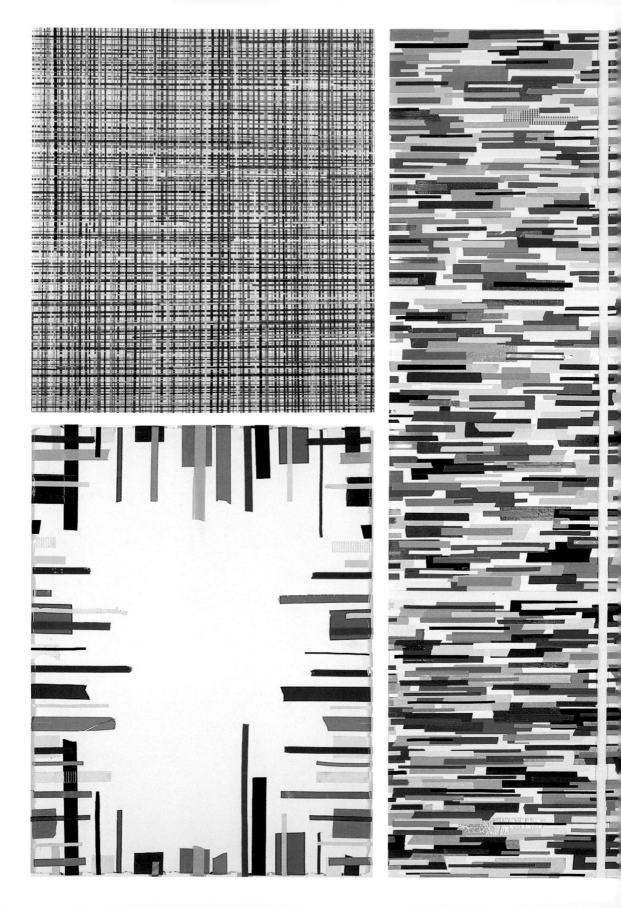

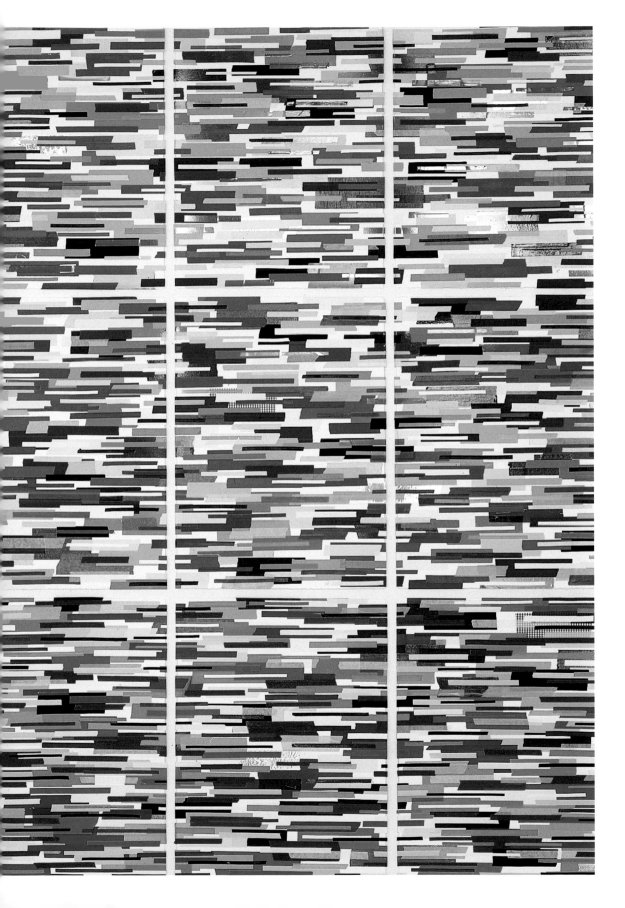

DO-IT-YO
CHAPTER

JRSELF

175 USES FOR DUCT TAPE

collected by Joe Hudson—State of Maine [USA]

www.thezac.com/ducttape

1. Hanging posters
2. Decorate book cover
3. Fix broken tail light on vehicle
4. Twist a long piece into rope
5. Tape wires down on floor or out of the way
6. Reattach rear view mirror
7. Repair cracked winshield/window
8. Patch ripped clothing
9. Hide unsightly wallpaper seams
10. Repair broken hoses
11. Repair broken fan belt
12. Use as art medium
13. Fix broken book binding
14. Band-Aid for really big cuts
15. Attach leg splint to broken leg
16. Wallpaper your house – may be slightly expensive, but well worth it for the resulting sophisticated look
17. Reinforce pages in 3-ring-binder
18. Fold in half and use as bookmark
19. Disk labels
20. Hinge on cabinet door
21. Repairing leak in tire or inner tube
22. Taping annoying people to walls, floor, ceiling, or bed
23. Holding together computer cases
24. Hold up exhaust pipe
25. Repair upholstery
26. Make lawn decorations
27. Roll into a ball for hockey practice
28. Mark lines on a sporting event field
29. Clothing – all sorts
30. Can be use to wrap duct work, but does not seal or hold up ducts very well
31. Use to pull unsightly hair or blackheads
32. Patches holes in vinyl siding
33. An entire roll can be used in place of a bedroom door to keep someone in for hours
34. Twisted correctly, can be used as a billy-club
35. Wrapped around newspaper to make a dog chew toy
36. Holding on book covers
37. Reflective lettering
38. Mute function for humans
39. Climbing rope
40. Earrings
41. Cover old pocket folders – lasts forever
42. Shoe designs
43. Girdle
44. Sealing envelopes in case you hate the taste of envelope glue
45. Great way to keep the wigs on mannequins
46. Better than hairspray
47. Seat belts that'll really keep the kids still
48. Make the stapler obsolete
50. Putting up Christmas lights
51. Why bother with waxing...
52. Add several layers to your car bumper for a much safer ride
53. Fix vacuum cleaner hose
54. Tape ski boot to your ski when the binding breaks
55. Repair seams of ski gloves
56. Wrap around your waist when your zipper splits in a one piece skisuit
57. Lift and separate when you don't want to wear a bra or can't have straps showing
58. Hold temple onto eye glasses
59. Make a wallet out of it
60. Hold car hood shut
61. Patch hole in canoe
62. Fixing sets for the school play
63. Making props look more realistic
64. Hold mics onto the mic stands
65. Re-enforce the phone cord
66. Hold batteries in remote control
67. Stick pictures up in your locker
68. Fix holes in your Airwalks
69. Hold pens together
70. Belt
71. Wrap your ankle for sports
72. Can be used in place of handcuffs
73. Rings
74. Hold file cabinet together
75. Makes great bumper stickers with a Sharpie
76. Hold shoe laces together
77. Can replace shoe laces
78. Can be used in place of Velcro
79. Can be used to put back a shreaded term paper together
80. Stop your jeans from fraying
81. Hair ties
82. Hold spikes to your cleats
83. Necklace
84. Note cards
85. Remove lint from clothes
86. Hold car door shut

97. Tape plastic over broken rear window
98. Tape down ripped carpet
99. Tape sole of ratty sneaker to body of sneaker
100. Use it as a Biore-Clear-Up-Strip
101. Practical joke toilet paper replacement
102. Makes a good bib
103. Put it on your lawn and paint it green
104. Mouse trap
105. Fly paper
106. Tape your little brothers' mouths shut
107. Use as vinyl flooring
108. Cover rust holes in your car
109. Roofing shingles
110. Make a clothes line
111. Window coverings
112. Use as roof rack on your car for carrying luggage and other items
113. Fix a broken plate
114. Patch a hole in your swimming pool
115. Make a swing for your kids
116. For the annoying mother-in-law
117. Lock people into their house, school, office, etc.
118. Hold your car bumper in place
119. Seat covers in your car
120. Fix holes in your sock
121. Earmuffs
122. Repair work gloves
123. Home security system – tape up doors and windows
124. Watch band
125. Wrap a soda can or bottle in duct tape to keep it cold
126. Makes stylish notebook decorations
127. Use it to fix old instruments
128. Use it as a dog, cat, rabbit, frog or lizard leash
129. Hold on toupees
130. Duct tape disturbing students to their seats
131. Reupholster the roof on a convertible
132. Attach it, sticky side out, to the end of a fishing rod, as a way to get pennies out from behind the couch
133. Surgical bandage
134. Fix a cigarette that is broken at the filter
135. Use it as a substitute for Bondo
136. Makes streamers for bicycle handlebars

137. Toilet seat cover
138. Makes great posters with the aid of magic markers
139. Make a sheet for your bed
140. Use to make the lines in the middle of the road
141. Make a space suit out of it so you can walk on the moon
142. Make a hat
143. Use instead of toilet paper on halloween
144. Make a wallet chain out of it
145. Stare at it and try to find new uses
146. Write on it and stick to someone's back
147. Put a few rolls on their side and roll them to have a duct tape race
148. Use it as hockey tape
149. Use to keep the cover of an old ice-cream maker securely attached
150. Cut a hole in a piece of cardboard, wrap duct tape around it and get a really inexpensive original looking picture frame
151. Make a pouch and attach it to a door so you can hold stuff
152. Waterproof sun screen for bald men
153. Patch holes in soft top jeeps
154. Resurface your trampoline
155. Use it to tape 10 year olds with sugar highs to trees during boyscout trips
156. Emergency limb replacements
157. Prostetics
158. Make fantastic puppets and other toys
159. Can be used to clean the floor when no vacuum is available
160. S&M
161. Make a ball
162. Repair trim on cars
163. Halloween costume
164. Patch up fish tank
165. Waterproof footwear
166. Repair leak in pilot gas line
167. Gagging device
168. Pinstriping
169. Use to keep Clinton's pants up
170. Wrapping Christmas presents
171. Patch a hole in a tent
172. No need for lunch box, just tape all your food together
173. Plant holder
174. Make a neck tie or a bow tie out of it
175. Chastity belt

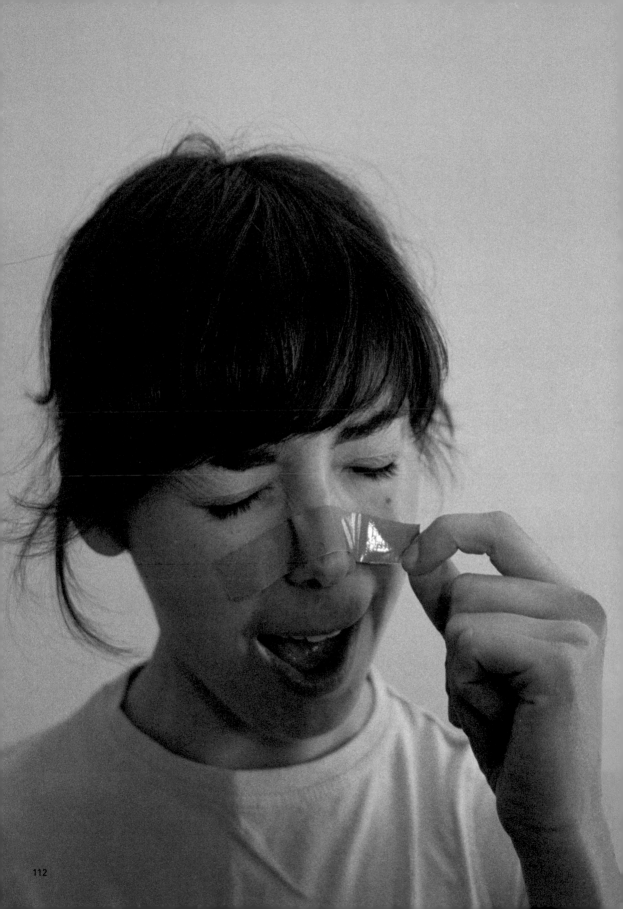

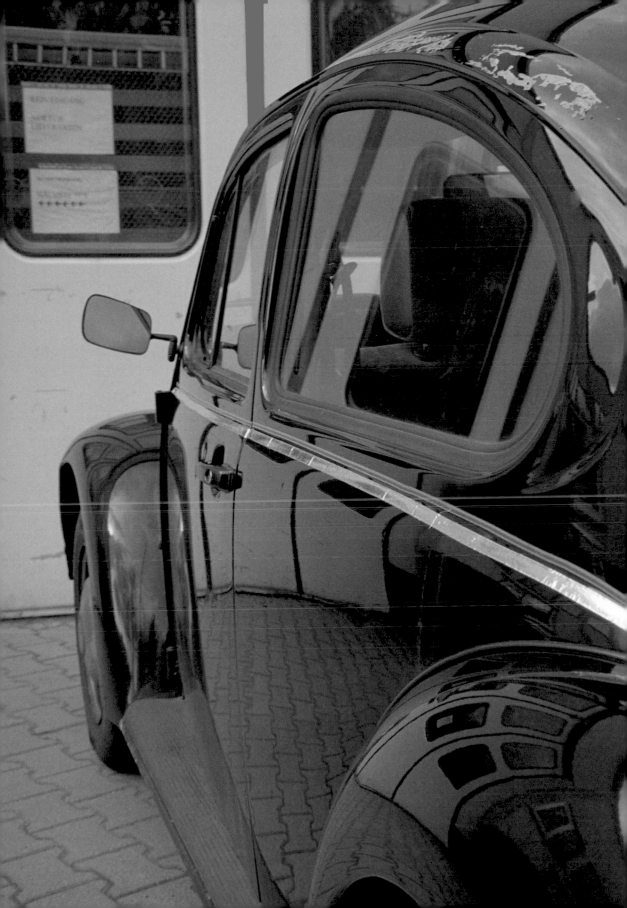

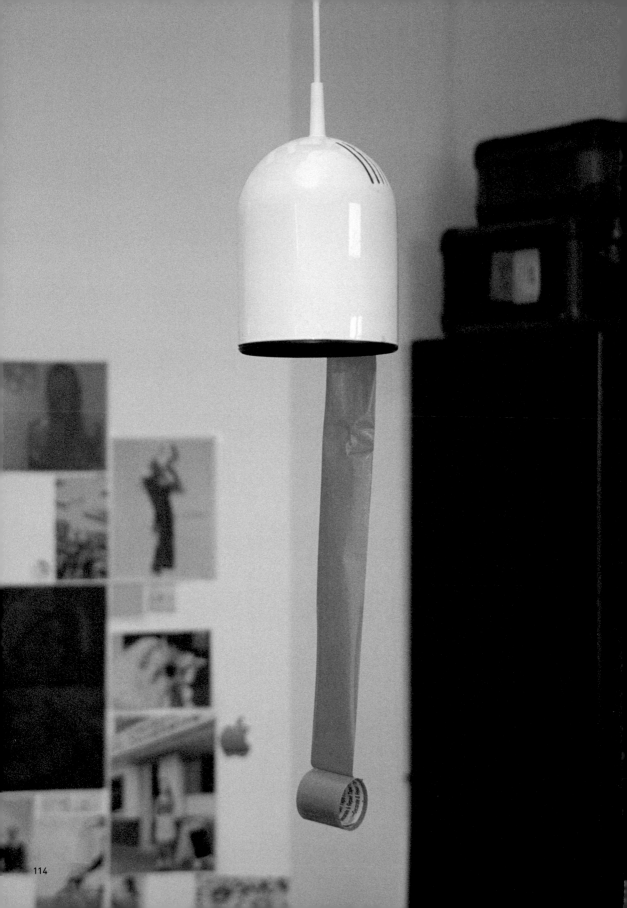

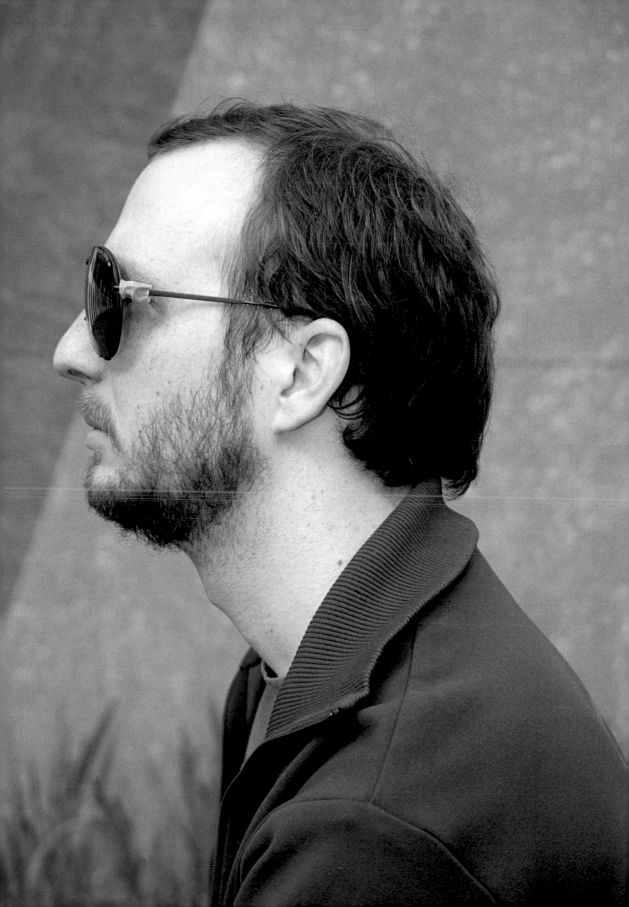

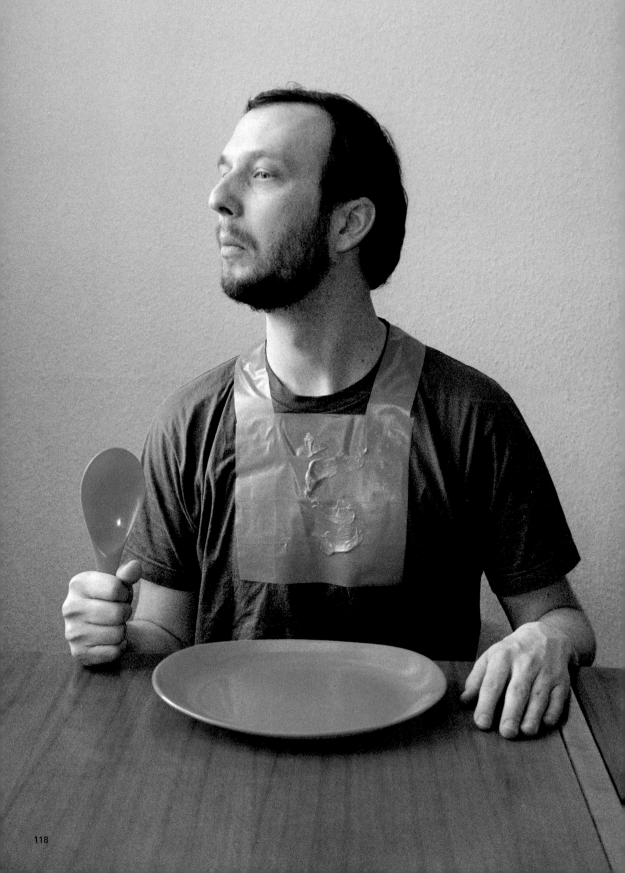

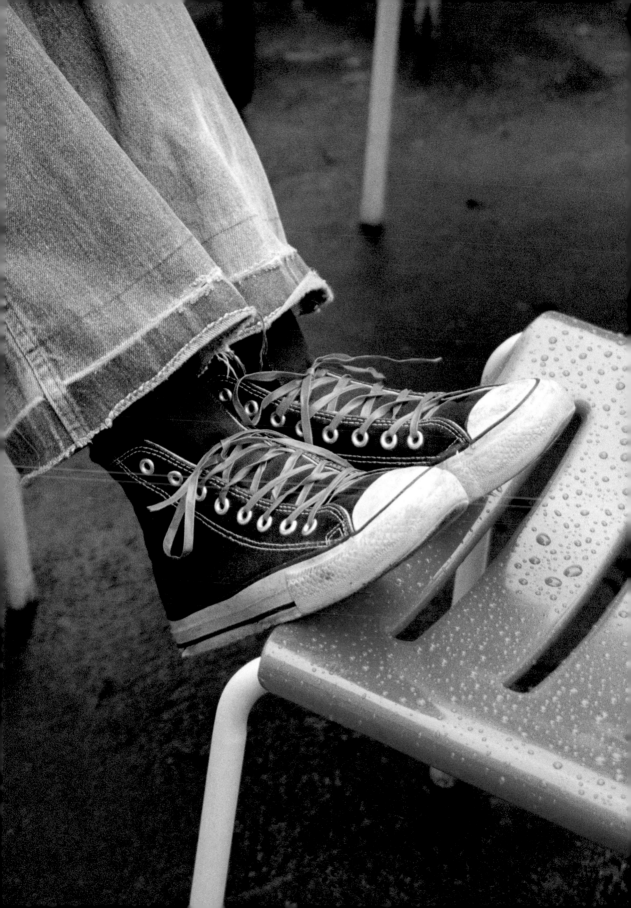

TAPE
ILLUSTRA
CHAPTER

TIONS

RETOUR
RETOUR
RETOUR

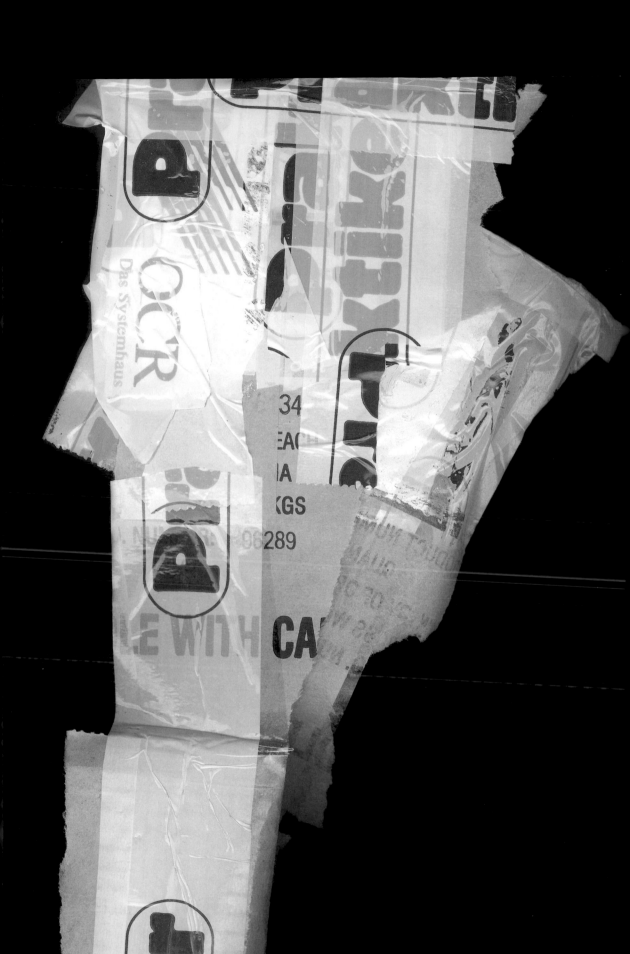

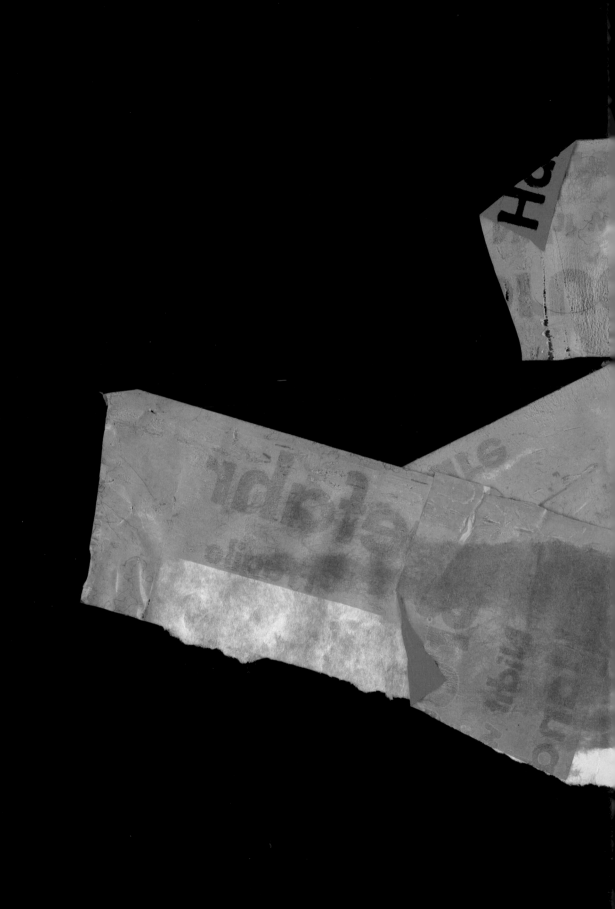

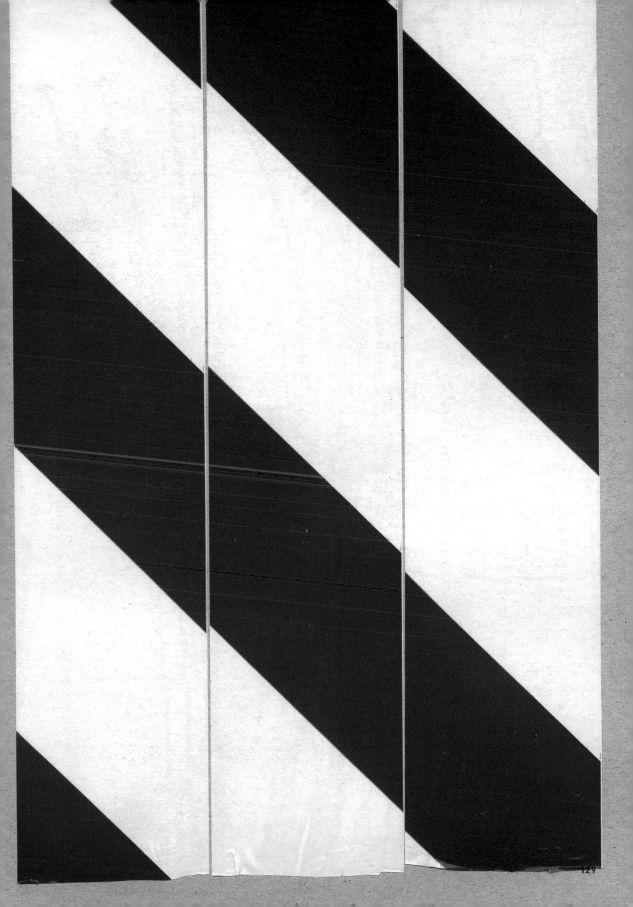

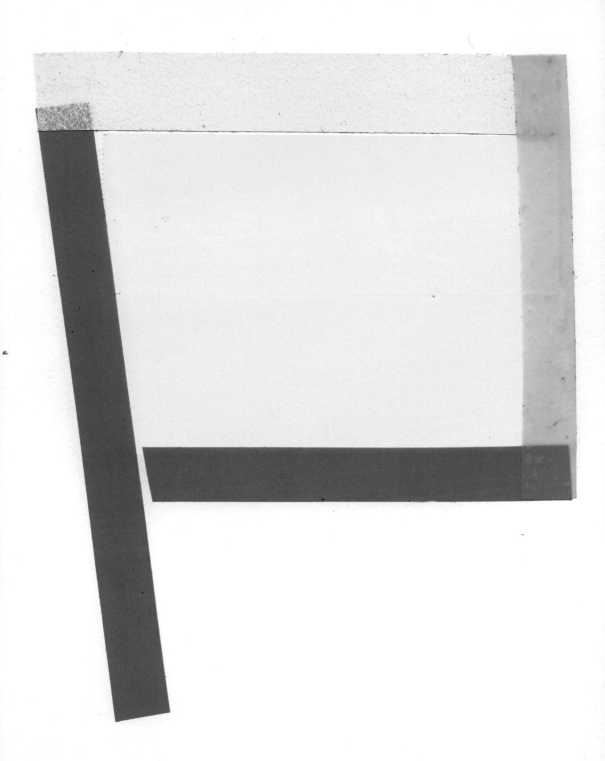

GEMESSENER SATZ
Y MEASURED SET
PAIRE D' ORIGINE
EDIDO EN FÁBRICA
URATA IN FABBRICA

ORIGINAL GEMESSENER SATZ
FACTORY MEASURED SET
JEU APPAIRE D' ORIGINE
JUEGO MEDIDO EN FÁBRICA
SERIE MISURATA IN FABBRICA

Emballage scellé

Si le cachet est endommagè, verifier immédiatément le contenu, avant d'émarger l'accusé de réception.

Paketsiegel

Bei verletztem Originalstreifen bitte vor Unterzeichnung der Empfangsbestätigung sofort den Inhalt auf Vollständigkeit überprüfen.

Sealed Package

If seal has been tampered with do not give clear receipt, or examine contents in presence of expressman.

SENE
SU ET
ORIG NE
EN FÁ RICA
IN FABBRICA

ORIGINAL GEMESSENER SATZ
FACTORY MEASURED SET
JEU APPAIRE D' ORIGINE
JUEGO MEDIDO EN FÁBRICA
SERIE MISURATA IN FABBRICA

ORIGINAL
FACTO
JEU A
JUEGO
SERIE M

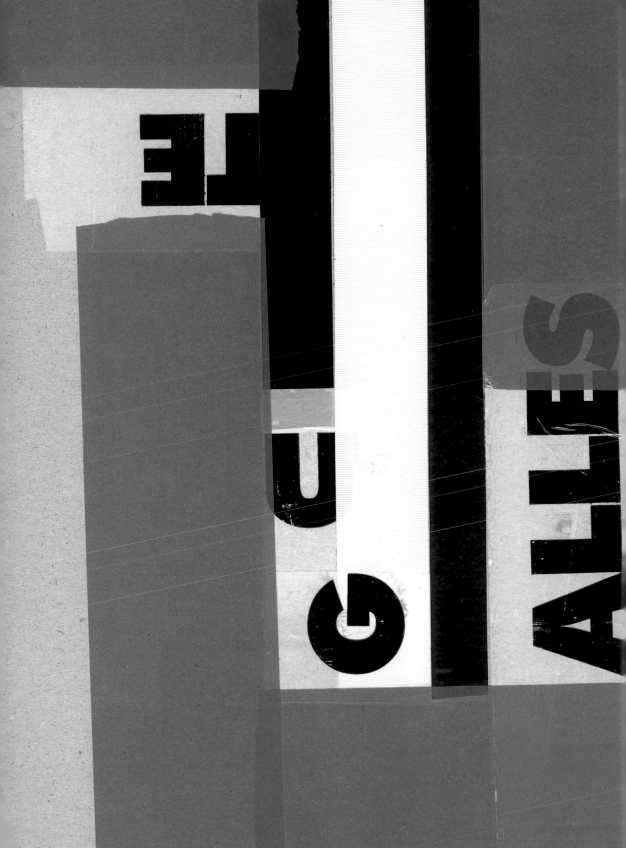

herheitsband

Sic

**Bitte das Paket vor Annahme
auf Beschädigung des**

Sicherheitsbandes

prüfen.
**Bei festgestellten Beschädigungen diese auf
dem Anlieferschein des Spediteurs vermerken.**

erheitsband

Sich

**Bitte das Paket vor Annahme
auf Beschädigung des**

Sicherheitsbandes

prüfen.
**Bei festgestellten Beschädigungen diese auf
dem Anlieferschein des Spediteurs vermerken.**

ZEITUNG FÜR DEUTSCHLAND

ZEITUNG FÜR DEUTSCHLAND

ZEITUNG FÜR DEUTSCHLAND

134

ZEITUNG FÜR DEUTSCHLAND

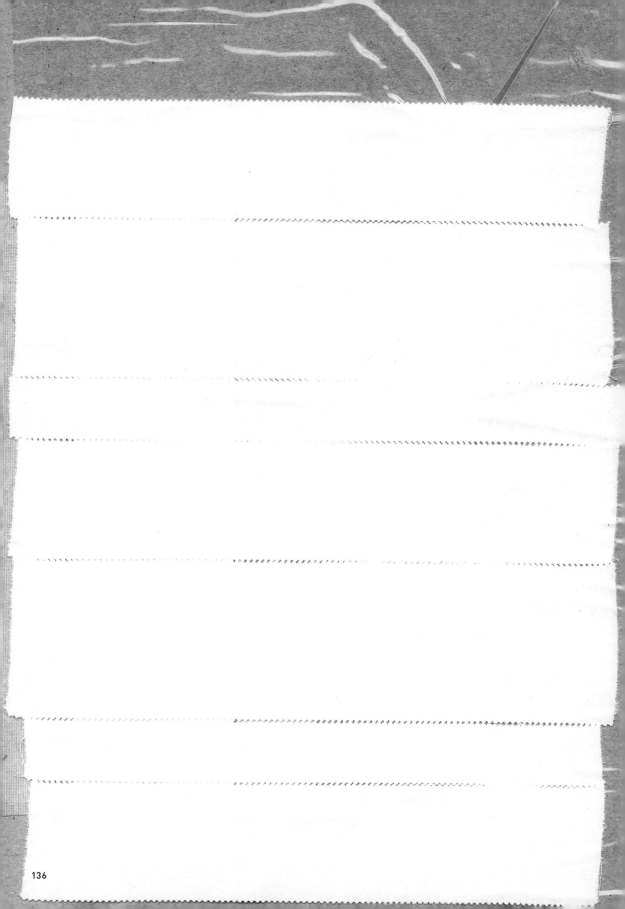

65670 DE
A0010000
TOLOMEO TAVOLO INCANDESC. AL.

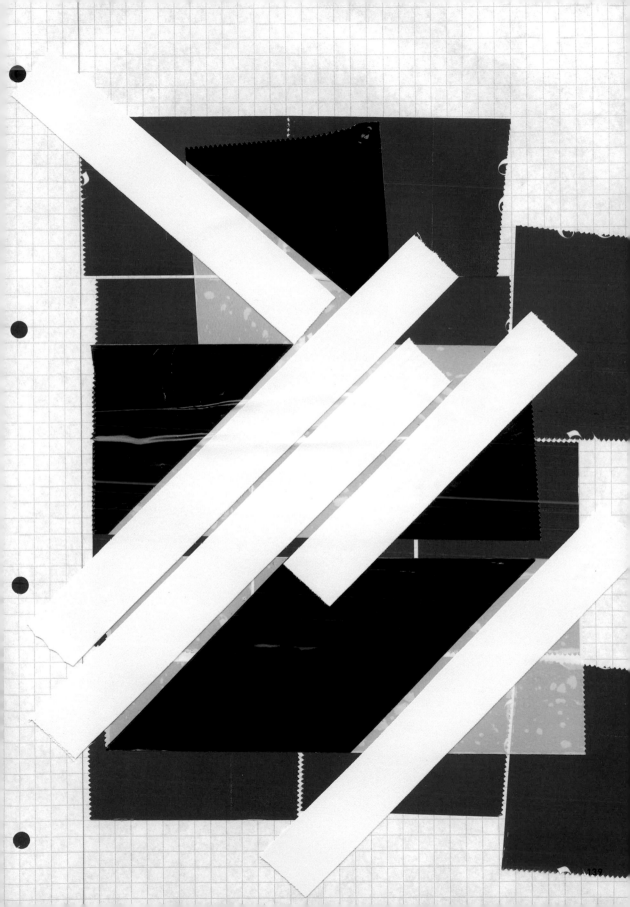

139

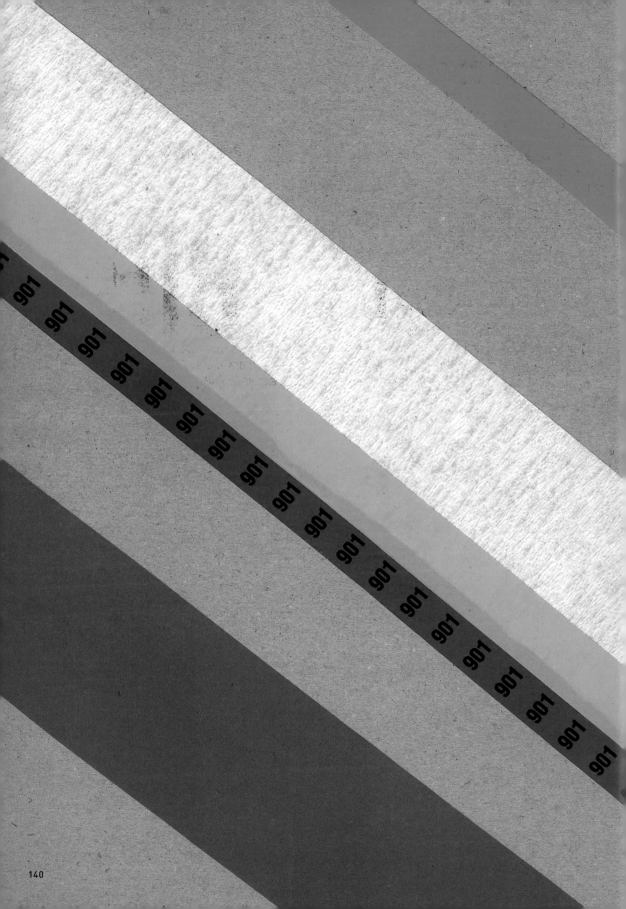

TEXT CHAPTER

TAPE ART – SYMBOL OF AUTONOMY

by Gregor Maria Schubert—Frankfurt/M [DE]—Journalist

Some artists have been using adhesive tape as material for decades, but it's popularity is growing so fast that it is now possible to talk of a »tape art« movement. But it is actually the material properties which cause every kind of artist and designer to discover the formal and conceptual relevance of adhesive tape for their work.

In the beginning adhesive tape was nothing more than a popular item of practical use; one that could be used in almost any situation. Adhesive tape was originally developed by the US Army and was soon being used for all sorts of repair work. And by the early 1950s, nearly every American household owned a roll of adhesive tape; a situation which later made its way across the Atlantic.

The outstanding usefulness of fabric tape, deep rooted in the consumer culture promised certain relief of day-to-day work and therefore, became an elementary object in numerous studios and agencies. Since then, adhesive tape has become a standard tool and sits alongside brushes, scissors and pencils in every toolkit.

The first artistic use of adhesive tape, until then used as a practical item, occurred in the explosion of styles during the post-modern period. What started as just an all-round tool, was released from its restraints thanks to the material expansive working methods of the avant-garde period after 1945. From this period onwards, adhesive tape was also supposed to be viewed aesthetically. It is true to say that creative dialog was still not concentrated on the usually single-coloured industrial product. But the materials with valuable properties and consumer origins were gradually becoming the focus of attention of painters and object artists. The pioneers of this visual design form include: Robert Watts, who was already exploring the optical effect of adhesive tape alongside aluminium foil for his basic material analytical research in the 1950s, the Fluxus artist Diter Rot, who made the objective triviality of various materials his artwork, and ultimately Joseph Beuys. Basically, tape can be found on many canvases, whether it is in assemblages, on sketches or as part of wild material collages. However, adhesive tape still remained a marginal phenomenon, which was usually used next to and not on the canvas. It has only been during the last two decades that this artistically unused everyday item has become a medium for conceptual artistic ideas. Although being of a temporary nature with an air of DIY aesthetics, the suggestive power of adhesive tape is quite considerable. It was hardly a surprise when the young Russian artist David Ter-Oganyan wrapped duct tape around a Coke can and

focussed the meaning of his work onto an explosive device by using a cheap timer and a label reading: »This is not a bomb«. Because you can never tell.

The imagination of adhesive tape knows no boundaries. It reaches from bondage, amateurish patchwork and tape as a subversive self-help instrument (giving it somewhat of a political touch) up to the obvious presumption that it is simply used for repair work. In the case of Thomas Hirschhorn, as cheap packaging material for the packaging industry. The Swiss artist has developed a technique to integrate items of everyday consumerism into art. Adhesive tape, aluminium foil, polystyrene, cardboard and similar cheap materials place the emphasis of his work on the marginal things in life. This may provoke images of homelessness and of worthless handicrafts; his actions are definitely not free from ethical-philosophical principles. And it seems as if his objects are only held together by a roll of adhesive tape.

The adhesive tape works of his compatriot Nic Hess are the sober and abstract, alternative to the brash, political metaphors in Hirschhorn's symbolic artwork. This is also true for the language. Hess's concept is to underline the (hidden) beauty of the material. In his spacious installations, he normally uses adhesive tapes in various colours, which are stuck to the walls, ceiling and floor as a semi-abstract play of forms. The many unfathomable signs of everyday life make his work what it is: a crossover of brand logos, quotations and playful interaction with his immediate environment. And a razzmatazz of colourful adhesive tape stripes.

The Scottish artist Jim Lambie takes his adhesive tape on a polychrome ramble through the floor landscapes of various exhibition houses. Besides objects of everyday use like record covers, flea market articles and things he finds on waste tips, he is mainly interested in using household articles with adhesive tape as the central design instrument. In contrast to Hess, his constructivist design of taped colour levels is the primary component of the installations. Lambie is only able to achieve his typical effect due to the extremely precise usage of adhesive tape stripes: His installation art is a psychedelic intoxication of loud colours.

Quite the same applies to the floor art of Beat Zoderer. His space designs are the result of a down-to-earth rationalism with no interest in the physical as a sense experience. He prefers geometry. His extensive, object-free space installations with their fully

organised pattern of straight lines might be the most graphical in regard to adhesive tape.

The Russian artist Valery Koshlyakov is considered to be the painter among the tape artists. He usually uses brown packaging tape normally used for cardboard boxes. His canvases are walls, cardboard boxes, fabrics and plastic foil. Only Koshlyakov has been able to create a figurativeness from this which possesses an astonishing sensuality despite the cheap material. Besides his architectural presentations, he particularly uses famous pictures like Leonardo da Vinci's Mona Lisa as templates for his collage-like art quotations.

The photographer Florian Böhm does not work with adhesive tape, instead he discovers and photographs it. Trivial things become art or are just perceived as art. His everyday observations are aimed at things everyone knows but has never really noticed. And all of a sudden they are turned into ready-mades of urban life: the motorcycle with its seat temporarily held together with packaging tape or the wind guards made of gaffer tape on a scooter's handles. Ultimately everything is art. You only have to believe in it.

TAPEHUNTER

by Max Küng—Zurich [CH]—Journalist

I froze in front of the shelf, shopping basket in hand and just stared. There I was in Tokyu Hands in Shibuya, an overcrowded area of Tokyo that can drive you mad within minutes. Tokyu Hands is, how shall I put it, maybe the best shop on earth. Here you can find everything you might ever need – more or less urgently – for your home spread over seven floors. A computer-programmed robot kit for example. Or a knife made of Damascus steel. Or accessories of the JFA, the »Japan Frisbee Dog Assoiction«. And adhesive tape. Every type of adhesive tape you can imagine or wish for.

So there I stood staring at the display, empty shopping basket in hand, paralysed by the gigantic selection. They had adhesive tape in wood design. Smooth. Rough. Golden. Shocking green. Pink. Broad. Narrow. Large rolls. Small rolls. Thick with textile structure. Very, very thin silver foil adhesive tape, which I believe Anselm Reyle would like a lot. They just had too many different types – and what really hindered me from buying one was: I already had them all.

And they had changed my life. At least I think so. It is now nearly seven years since I first came to Japan and walked into the Tokyu Hands temple, stood in the same place and just put one roll of each type into my shopping basket (which severely dented my credit card and caused my luggage to be overweight). This purchase made me extremely nervous since the prey was big and wonderful. I had always collected adhesive tape. The first thing I always did when I arrived in a new city was to go to the shops which offered this artificial material. In a ship accessory shop down at the harbour, in the pretentious city of Deauville on the Normandy coast, I found an approximately eight-centimetre wide special tape for decorating yachts, in four colours (different shades of green which very much reminded me of a »Saint Etienne« LP cover), a real jewel. At »B&H« on 34th street in New York, I bought tape with the inscription »Caution Cable«, which I immediately stuck onto everything near cables. In Milan I found the wonderful chocolate-brown tape from the Italian company Syrom (also worth a visit: www.syrom.it). They were souvenirs. They were trophies. I proudly collected them.

But I had never seen a selection like the one in Tokyu Hands. For example, the super-ultra-tough insulating tape from Yamato (with self-advertising: »Excellent adhesive strength and electrical insulation. Durable, no affect by climate. The colors hardly

fade away. High quality vinyl chloride prevents itself from burning easily.«) – By the way, Yamato is also the manufacturer of adhesive tapes and other things used in Japanese nuclear power stations; a fact which sometimes reassures me, but sometimes rather disturbs me.

Or the black and yellow stripped adhesive tape from Nitto (self advertising: »They look the same, but they're very different... NITTO tape can be used in any situation.«)

Or the Okamoto tape available in every hip colour (the company also produces condoms on a large scale: www.okamoto-condoms.com). Okamoto, just the sound of the name makes you want to buy it.

Back at home, I stuck the self-imported tapes from the Far East onto pretty much everything. Furniture. Trainers. Hatchbacks. I was on a real customise- your-things with adhesive-tape-trip. I mean it is quick and easy. Individuality made simple. Tear. Rip. Stick. I especially stuck strips of the synthetic material onto homemade CD covers for burnt CDs. I then imposed these CDs on women who had not asked for them. Okay, one of these women later fell in love with me and I am pretty damn sure this wasn't because of the music, but because of the extremely cool adhesive tape on the CD cover. Not that she ever said so. She never said: I wanted to get to know you better because you collect adhesive tape and this seems to be a very interesting hobby, better than collecting trainers or stamps or some insects. No, she never said that. But that's how it was. I know it. And we have been together ever since, like adhesive tape. Pretty good adhesive tape.

These were my thoughts while standing in Tokyu Hands with the empty basket dangling in my hand and my girlfriend lingering somewhere in the department with the clay beer mugs. I had to smile and in the end didn't buy a single roll, since I already had a whole cupboard full back at home. And anyway, my favourite adhesive tape at the moment is not from Japan, but from the USA. It is the Reflectix aluminium tape from Markleville, a backwater in Indiana with 383 inhabitants and neighbouring communities with names like Sulphur Springs. With Reflectix you can even repair satellites in outer space. I definitely always have a roll of it on me. And one day, I have promised myself, I will travel to Markleville. And then I will shop till I drop.

TAPE EPISODES

by Sven Ehmann—Berlin [DE]—Editor

New York, Lower Eastside. Late summer. The towers are still standing and underneath the Brooklyn Bridge a new club has opened its doors. The large-area projections on the walls are still quite a novelty. Upstairs on a gallery it is possible to watch art videos on small screens. But this is definitely not a place for dancing, the people just stand around, talking and observing.

One of the guests is monitoring the situation very carefully, sometimes appearing from the shadows, he looks to the left and then to the right, approaching slowly. Sometimes he stands directly in front of another guest or a group of guests, provoking them with his very presence. He is holding a roll of gaffer tape in his hand.

He waits for the right moment, for the last slightest movement, for the split second in which everything is perfect. And then, he pounces forward, ripping 20 or 30 centimetres of tape from the roll, fixing the people in their pose, at this exact moment. He hits and sticks. An arm resting on a stomach, shoulders pushed towards the back, crossed legs, folded arms, holding hands. He highlights the most normal of all gestures. Black tape on sweatshirts, jeans and skirts.

The people are shocked; their last bit of privacy has been violated. He has come close, very close, too close. They do not know whether they should defend themselves, push him away or shout at him. But as soon as he has stuck the tape, he is off again. He steps back, admires his work with a cheeky grin and disappears into the crowd.

Now the people start to talk, shaking their heads, laughing, searching for his face. Those who have been stuck, start to remove the tape with the tips of their fingers. It falls to the floor, onto chairs, gets stuck to the soles of shoes which carry it outside.

What is happening here is situat[i]onial. Guerrilla-style, spontaneous, surprising, aggressive, entertaining, fleeting... It is a performance in a public space, made for the moment and for just a few eyes. Not for galleries, not for curators, collectors, critics, but only for those who experience the moment and tell of it.

The talking continues. The talk is of being attacked, a performative assassination. Of insolence, wilful damage, a joke, ...of a photograph. A photograph? The tape artist as a photographer? Someone who watches, waits and prances like the most famous and reserved of all documentary photographers? A Cartier-Bresson with gaffer tape?

Actually, it is about the decisive moment and of how to fix this moment in a split second, to make it visible and create awareness. But not at the same distance as provided by a photographer's 50mm lens, but in direct confrontation between the observer and the observed, with the absolute closeness of contact.

It was not until years later that tape came that close again between Milan and Berlin and in an exhibition of the Parisian Foundation Cartier. The collection of Grit and Jerszy Seymour turned the idea of the New Yorker situationist into a production and design principle and for the fashion world, a small but attention grabbing revolution. Seams are a thing of the past. T-shirts, skirts and trousers are now held together by colourful, flexible, washable adhesive tape. The tape collection has a constructed but also playful character. It displays its construction as openly as the Centre Pompidou.

Adhesive tape as a material, as a sketch pad, as a medium. Or as a cage, perhaps even as a weapon? Artists such as Mauricio Cattelan and the performance group Poni use adhesive tape more aggressively. It is not a charming stripe or an elegant tape seam which they present. Instead they stick themselves to walls just above the ground and wait to see if gravity can conquer the adhesive force of a multitude of adhesive stripes. There they hang waiting and everybody waits with them until they eventually break away from the wall with a menacing sound of ripping.

Akay uses tape in a much quieter way. In Berlin, in the autumn, the Swedish urban artist has an exhibition in a small gallery in Prenzlauer Berg. He had previously sat for many nights in this room, sorting out his material, getting a feeling for the room, sketching. And then during the last two nights he changed this white cube into an extensive urban collage, one wall has been covered over and over again with prints, one has been wallpapered with screenprint posters and on the third are four large words written with black and brown tape: »I am very sorry«.

Scotch®
Automotive Masking Tape 3400

Product Data Sheet

Updated : July 2000
Supersedes : February 1997

Product Description	Scotch® Tape 3400 is a chamois coloured creped paper masking tape for good high temperature masking and is particularly suited for use in the automotive industry.
Applications	The temperature performance of the Scotch® Tape 3400 allows air drying and oven curing of paint up to 140 °C for one hour for a single pass, or at lower temperatures for repeat bake cycles.

Physical Properties
Not for specification purposes
(Calipers are nominal values)

Backing	Latex Saturated Heavy Weight Creped Paper
Adhesive	Controlled Crosslinked Rubber Resin
Shelf Life	12 months from date of manufacture by 3M when properly stored in a clean dry place at 21°C & 50 % Relative Humidity.

Product Characteristics
Not for specification purposes

Thickness AFERA4006	0.175 mm
Adhesion to Steel AFERA4001	10.5 N/25mm
Tensile Strength AFERA4004	110 N/25mm
Elongation AFERA4005	10.5%
Temperature Performance	140°C Satisfactory performance and clean removal of Scotch® Tape 3400 will be achieved at varying temperatures/time exposure on many substrates. Tests should be conducted to establish Scotch® Tape 3400 performance parameters in your process conditions. The optimum level for product performance and easy removal is at 140°C for 60 minutes.

INDEX
ETC.

INDEX WITH BIOGRAPHIES, EXHIBITIONS AND CREDITS

Martí Guixé

born in 1964—started career in Barcelona and Milan as an interior and industrial designer. In 1994, periodically working as a design advisor in Seoul and living in Berlin, he formulated a new way to understand the culture of products. Guixé started to exhibit his work in 1997, work that characterises the search for new product systems; the introduction of design in food ambits and presentation through performance. His non-conventional gaze provides brilliant and simple ideas of a curious seriousness. He is based in Barcelona and Berlin and works as »ex-designer« for companies such as Authentics, Camper, Cha-cha, Chupa-Chups, Desigual, Droog Design, Imaginarium, Isee2, Pure Lustre and Saporiti.

Recent publications Martí Guixé, 1:1, 010 Publishers, Rotterdam [ISBN 9064504415]—Martí Guixé Cook Book, Imschoot Publishers [ISBN 9077362045]—**Exhibitions** MoMA, New York [USA], MuDAC, Lausanne [CH], MACBA, Barcelona [ES] and Centre Pompidou, Paris [FR]

»Do Frame« produced by do, 2000 **Author** Martí Guixé **Photo** Inga Knölke—»Autoband Tape« Produced by Galeria H2O, 1998 **Author** Martí Guixé **Photo** Inga Knölke—»Football Tape« Produced by Magis, 2004, Self production, not for sale, 2000 **Author** Martí Guixé **Photo** Inga Knölke—»CIA Communicacion Barcelona, Installation« 2002 **Author** Martí Guixé **Photo** Inga Knölke—»Guest Tape« CIA Communicacion, 2002 **Author** Martí Guixé **Photo** Inga Knölke—»Relax Tape« CIA Communicacion, 2002 **Author** Martí Guixé **Photo** Inga Knölke—»Plant Emulator 1.0 Tape« CIA Communicacion, 2002 **Author** Martí Guixé **Photo** Inga Knölke—»Plant Emulator Tape Installation« 2002 **Author** Martí Guixé **Photo** Inga Knölke—»Exhibition View 1:1« Guixé, Lima, Spazio Lima, Milan [IT], 2003 **Author** Martí Guixé **Photo** Inga Knölke—»Sketch Tape« Self produced, 2003 **Author** Martí Guixé **Photo** Inga Knölke—»Forever Agenda Tape« Self produced, 2003 **Author** Martí Guixé **Photo** Inga Knölke

Tape

Grit Seymour born near Berlin in 1966, grew up in communist Eastern Germany, being an active part of the underground cultural and political opposition movement. In 1988. she escaped to the west where she lived, studied and worked in the fashion capitals London, Paris, Milan and New York. After ten years as fashion designer and artistic director for various corporate fashion companies including Donna Karen, Max Mara and Hugo Boss, she opened her own designstudio in Milan in 2001. She started working together with her husband, Jerszy Seymour on their own experimental production »Tape« in 2003 as well as consulting for other international fashion companies. Grit currently works and lives between Berlin and Milan.

Exhibitions »Tape« Palais de Tokyo, Paris [FR], 2003—»Tape versus Crazy Horse« Paris [FR], 2003—»Tape 2« Officina Stendhal, Milan [IT], 2004—**Awards** »IWS Design Award« Germany, 1991—»Onward Kashiyama International Design Award« Tokyo, 1993—»IWS International Design Award« International, 1994

Jerszy Seymour born in Berlin in 1968, grew up in the multicultural concrete landscape of London as an integral part of the 80s street scene creating club flyers and as a DJ playing hip hop, electro, dub and ska in the underground club scene. In 1991 he was given a scholarship to the Royal College of Art where he developed his interest in design and sculpture. After leaving the college he traveled and lived around the world, during which time he fermented and formulated the ideas that would characterise his idiosyncratic creative approach. In 1999, he opened his workshop in Milan, where he started his own experimental productions including »House in a Box« in 2002, »Scum« in 2003 and »Tape« in 2003. In parallel he has designed for companies such as Magis, Nike, Kreo, IDEE, Sputnik, Covo, Swatch, Perrier, L'Oreal, and Smeg. His work has been exhibited in the Design Museum in London, the Vitra Design Museum in Basel and Berlin, the Pompidou Center and the Palais De Tokyo as well as in the renowned Gallery Kreo in Paris. His work is in the permanent collection of the »Fondation National de Art Contemporaine« France. He has given lectures at the Domus Academy in Milan, the Royal College of Art in London, and the Vitra Design Workshops in France. In 2000, he was awarded the Dedalus Award for European Design, and in 2003 the Taro Okamoto Memorial Award for Contemporary Art. Jerszy currently works and lives between Berlin and Milan.

Solo Exhibitions »Enter the Monkey« The Milan Furniture Fair, 2002—»Bonnie+Clyde« The Design Museum, London, 2002—»Lowlife« Gallery Kreo, Paris, 2003—»Welcome to Scum City« Gallery Facsimile, The Milan Furniture Fair, 2003—»Tape« Palais de Tokyo, Paris, 2003—»Welcome to Scum City Part II: Tokyo Style« IDEE Tokyo, 2003—»Tape 2« Officina Stendhal, Milan,

2004—»Mo' Scum« Denim Gallery, New York, 2004—**Group Exhibitions** »Design Now« The Design Museum, London, 2001—»Smash« The Milan Furniture Fair, 2001—»Living in Motion« The Vitra Design Museum, Weil am Rhein, 2002—»Somewhere completely else« The Design Biennale, The Design Museum, London, 2003—**Awards** »Dedalus Award for European Design« 2000—»Taro Okamoto Memorial Award for Contemporary Art« 2003

Collection Summer 2004 Models—Taylor [Ice] and Patrick [Fashion]—**Collection Winter 2004/05** Models—Laima [Beatrice] and Ferdi [Fashion]—**Collection Summer 2005** Models—Randall Dean [Fashion] and Anna Fox [Elite]—**For all Pictures** All Images A to the K—**Photo** Karen ann Donnachie—**Collage** Andy Simionato

Pieke Bergmans

Born in the Netherlands, March 23, 1978—Designer of all sorts, products, interiors, graphics and illustrations—She grew up in a creative family, with her father and grandfather who where both shoe designers and her mother an artist. Since she was a little girl, her father took her from school to travel all over the world, and showed her around in factories where she could help him design new shoes while enjoying the foreign cultures. That was the start of a lifetime fasciation for the combination of foreign cultures and design that lead to new designs. As she says: Even the design process is a journey. I try to discover and find things.—She works very closly with materials and the environnement she is in, which makes her work very personal and original. She calls herself a little airplain...or a Design Nomad because she is never fixed to a place; she and her work keep on moving.....

Education Graphic Design, St.Joost, Breda [NL]—Industrial Design at Design Academy, Eindhoven [NL]—3D Design, Arnhem [NL]—MA Design Products, Royal College of Art, London [UK]—**Recent Expositions** Exposition with Will Allsop, Valencia [ES], 2004—Ingo Maurer at Salone di Mobile, Milan [IT], 2004—Bloomberg, London 2004—Gala Fernandez Hidden Art at 100% Design, London, 2004—Bombay Sapphire 100% Design, London, 2004—British Council, Tokyo, Thailand and Moscow, 2004–2005—Rosenthal Design Award, Munich [DE], 2004—Beyond the Valley, London [UK], 2004—Aram Design Shop, London [UK], 2005 etc.—**Recent Nominations** Bombay Sapphire Prize, 2004—Rosenthal Design Award, 2004—**Recent Publications** Wallpaper—Frame—Form—Blast YDN—Vogue—Elle Decoration—London Times

© Pieke Bergmans »Re-Design« for the Rosenthal Design Award 2004—**Photography** Dieter Schwer

Oliver Kartak

Born in 1968—he lives and works in Vienna [AT]—formal training as a graphic designer—numerous projects in broadcast design, e.g. on-screen identities for German music channels Viva and Viva 2—numerous record cover designs both as a graphic designer and photographer—writer and director of the first feature film »Bruderliebe« in 2005 for Austrian television

Project realized in cooperation with Moritz Friedel—© **Photography** Oliver Kartak

Claudia Caviezel

Born in Zug, 1977 [CH]—Textile Design in Lucerne, HGKL, 1998–2002—Diploma Textile Design, 2002—**Work Experience** Stage at Studio Edelkoort,2002—Magazine »In View«, Paris, 2002—Styling for the Department Store Quartier 206, Berlin [DE], 2001—Installations and Illustrations for HGKL, 2003—Milani d&c, Industrial Design, Zurich [CH], 2003—Jakob Schlaepfer, Textile Design, St.Gallen [CH], since 2004—**Awards** Encouraging Award, Zug [CH], 2002—Special Award from Magazine »Hochparterre«, for architecture and design, 2002—Lucky Strike Junior Designer Award, 2002—Swiss Design Award 2003—Artist in residence, Swiss atelier in New York [USA], 2003—»Talente« International Design Award, Munich [DE], 2004—**Exhibitions** Museum of Modern Art, Zug [CH], 2002—Single exhibition »Georgette, Trevira, Serge & Hugo«, Erfrischungsraum

Lucerne [CH], 2002—»Tape it, scotch the plastic fantastic bag«, Shop Museum Bellerive, Zürich [CH], 2003—Löwenbräu-Areal, Zürich [CH]—»Designers Saturday«, Berlin, Wallpaper Design, Berliner Backfabrik—Swiss Design 2003, Mudac, Lausanne [CH]—»Auf die Taptete gekommen« Swiss National Museum, Zürich—»Talente«, International Trade Fair Munich [DE], 2004—»Flick Gut« Gewerbemuseum Winterthur [CH], 2004—»Tuchreform«, Winterthur [CH], 2004—»Art and Textile« Aarberghuus, Ligerz [CH], 2004

© **all pictures** Claudia Caviezel

Valery Koshlykov

Born in Salsk [RU], 1962—now lives and works in Moscow [RUS] and Paris [FR]

Solo Exhibitions—**2005** Nuvola [Cloud], National Museum Tretiakov Gallery—First Moscow Biennale of Contemporary Art, Russia—Project of MACRO, Museum of Contemporary Art, Rome [IT] and Gallery Orel Art Presenta, Paris [FR], catalogue—Ikonus, State Russian Museum, Saint-Petersbourg [RU]—**2004** Nuvola [Cloud], [Cecilia Casorati curator]—MACRO, Museum of Contemporary Art, Rome [IT], catalogue—Valery Koshlyakov, Davis Museum and Cultural Center at Wellesley College, Boston [USA]—Valery Koshlyakov, Museum Villa Haiss, Zell am Hammersbach [DE]—Paysage, lieu de vie, Mairie de Paris, Hôtel d'Albret, Paris [FR]—Empire de la Culture, Chapelle de l'Hôpital Saint-Louis de la Salpetrière, Orel Art Presenta, Paris [FR], catalogue—**2003** Héritage, Gallery Orel Art Presenta, Paris [FR], catalogue—Occupation d'élite [with S.Shekhovtsov], Galerie Regina, Moscow [RUS]

Selected Group Exhibitions—**2005** Russia 2, [curator M.Guelman], First Moscow Biennale of Contemporary Art, Central House of Artists, Moscow [RU]—Paysages. Constructions et simulations [E.Lunghi curator], Casino, Luxembourg—Forum d'art contemporain, Luxemburg—Focus Istanbul, Martin Gropius Bau, Berlin [DE], catalogue—Russia, Guggenheim Museum, New York [USA]—**2004** Moscow Berlin/Berlin Moscow 1950-2000, Gropius Bau, Berlin [DE] and State Historical Museum, Moscow [RU]—Award of the State of Russia [exposition], State Tretiakov Gallery, Moscow [RU] Na kurort! Russische Kunst Heute, [G.Nikitch curator], Kunsthalle, Baden-Baden [DE], catalogue—7 Sins, [Z.Badovinac, V.Misiano and I.Zabel curator], Museum of Contemporary Art, Ljubliana [SL]—**2003** Il ritorno dell'artista, 50esima Biennale di Venezia [V.Misiano curator], Russian Pavillion, Venice [IT], catalogue—Festival of Contemporary Art Kliazma, [V.Dubossarsky curator], Moscow Venise—**2002** Iconografias Metropolitanas, XXV Bienal de São Paulo [V.Mesiano curator], São Paulo [BR]. catalogue—Davaj!, From the Free Laboratory of Russian Art [P. Noever curator], Berliner Festspiele, Berlin [DE] and Museum of Applied Art, Vienna [AT], catalogue—Contemporary Russian Painting [E.Selina curator], Small Manege, Moscow [RU], catalogue—IX. Rohkunstbau, Schloss Gross Leuthen [DE] **2001** Moscow: Paradise 2001, Galerie Krinzinger, Vienna [AT]—**2000** Freezing Pole, Russian Art of the 90s [A.Erofeev curator], Ecole des Beaux-arts, Paris [FR]—South Russian Wave, State Russian Museum, St. Petersburg [RU]—Ludwig Museum at the Russian State Museum, Saint-Petersburg; Gallery Guelman, Moscow [RU], catalogue

All pictures are Courtesy of Gallery Orel Art Presenta, Paris—www.orelart.com

Peter Regli

Realized Projects—**228** Les Urbaines Festival, Lausanne [CH],12/2004—**212** 25th Theaterspektakel Zurich [CH], 08/2004—**221** Kunsthof Zurich [CH], 07-09/2004—**225** Among Others 05, Künstlerhaus Dortmund [DE], 05/2004—**208** Experiencia de Accion, Depto. de Interventiones Publicas, Havana [CH], 11/2003—**207** Irgandaswia, Chur [CH], 10/2003—**206** Bronze Rocks, Work in Progress, Zurich [CH], October 2003/2004—**202** Crash Composition, Zurich [CH], 06/2003—**201** Okayama [JP], 10/2002—**200** Reussdelta, Uri [CH], 08/2002—**197** Mountain Prayer, Willisau [CH], 09/2002—**195** Roter Pfeil, Runaway Train, Switzerland, 08/2002—**147a** Museum of Modern Art, Queens [USA], 06-09/2002—**199** Public Plaiv, Zuoz [CH], 03/2002—**192** Pirate Flags, Zurich [CH], 03/2002—**187** Le Lignon, Geneva [CH], 06/2001—**186** Planet22, Geneva [CH], 06/2001—**180** Uristier, Altdorf [CH], 03/2001—**179** Uebersee, 08/2000—**177** Lake Zurich,05/2000—**178** Baden, Switzerland, 05/2000—**175** New York City, 01/2000—

174 Post no Bills, Manhattan [USA], 01/2000—**172** Wall clocks, New York City [USA], 12/1999—**171** Museum for Concrete and Constructive Art, Zurich [CH], 1999—**170** Manhattan Island, New York [USA], 09/1999—**169** La Paloma, Museum Helmhaus, Zurich [CH], 06/1999—**167** One/in God we trust, Green River, Utah [USA], 06/1999—**158** Red Ladder, Bueyeros, New Mexico [USA], 05/1999—**156** Cattle Scrabble, Bueyeros, New Mexico [USA], 05/1999—**146** Swiss Mill, Zurich [CH], 12/1998-02/1999—**142** Financial Building, Kt. Zurich [CH], 11-12/1998—**162** Rugby, North Dakota [USA], 09/1998—**157** Outside Las Vegas, Nevada [USA], 07/1998—**154** Wendover, Utah, 09/1998—**152** Great Salt Lake Desert, Utah, 09/1998—**151** Roswell, New Mexico [USA], 07/1998—**150** Geographic Center of Nevada [USA], 08/1998—**147** Railway watch, 10/1998—**140** City Hall, Zurich [CH], 04/-05/1998—**136** Kunstmuseum Lucern [CH], 12/1996-01/1997—**138** Hollywood Hills, Hollywood [USA], 01/1998—**135** Museum, Helmhaus, Zurich [CH], 04/-05/1998—**133** Kasko/Nonlieux, Basel [CH], 01/-03/1998—**130** No camping, Switzerland, 1997—**121** St. Anna glacier, Switzerland, 09/1997—**102** Red carpet, Zurich [CH], 11/1997-05/1998—**100** Wind Needle, Gemsstock/Andermatt [CH], 10/1997—**092** San Gottardo, Switzerland, 09/1997—**089** Oberalp/Bornengo, Switzerland, 08/1997—**088** Oberalp/Surselva, Switzerland, 08/1997—**085** Rhone Glacier, Switzerland, 08/1997—**083** Rhone Glacier, Switzerland, 08/1997—**082** Park Bench, Uri [CH], 09/1997-1999—**081** Rhone Glacier, Switzerland, 08/1997—**080** Rhone Glacier, Switzerland, 08/1997—**079** Museum Helmhaus, Zurich [CH], 06/1997—**076** Piazza di Ferrari, Genoa [IT], 06/1997—**075/074** Diga Foranea, Calata Canzio, Genoa [IT], 05/1997—**072/073** Ospedale Psychiatrico, Quarto [IT], 05/1997—**071** Via Monterosa, Genoa [IT], 03/1997—**069/070** Scolio dei Mille [IT], 05/1997—**068** Porto di Genova [IT] 03/1997—**067** Porto di Genova [IT], 03/1997—**066** Porto di Genova [IT] 03/1997—**065** Porto di Genova [IT], 03/1997—**064** Porto di Genova [IT], 03/1997—**063** Porto di Genova [IT], 03/1997—**056** Comune di Genova [IT], 02/1997—**055** Comune di Genova [IT], 02/1997—**054** Comune di Genova [IT], 02/1997—**053** Comune di Genova [IT], 02/1997—**052** Comune di Genova [IT], 02/1997—**031** Ponte Brolla, Ticino [CH], 1996—**032** Ponte Brolla, Ticino [CH], 1996—**033** Valle Maggia, Ticino [CH], 1996—**034** Verscio, Ticicno [CH], 1996—**005** Kunsthof, Zurich [CH], 06/1996—**003** Neumuehlequai, Zurich [CH], 07/1996—**001** Sihlquai, Zurich [CH], 05/1996

Reality Hacking Nr.055, Genova [IT], March 1997—Series of 80 interventions with red, yellow, and grey tape
© **Photography** Peter Regli

Fulguro

Cédric Decroux born in 1976, Yves Fidalgo born in 1976 and Axel Jaccard born in 1977 now all live and work in Lausanne [CH]. They studied Industrial Design at the Écal, École cantonale d'Art de Lausanne from 1997 to 2001, in the same class. Their first professional project was an animated movie called «Motion Notebook» for Ronan and Erwan Bouroullec's exhibition at the London Design Museum in 2001. In 2002, Fulguro moved into a huge and empty tights factory in the neighbourhood of Lausanne. In the end of 2003, they moved into Lausanne's «city center». They go on developing projects in both graphic and object design by mixing fields together.

Florian Böhm

Florian Böhm, (b. 1969, Fulda, Germany) traces the iconography of unintentional forms and accidental expressions, which appear everyday as unique forms of urban pragmatism. He has exhibited his work at numerous international institutions including KunstWerke Institute for Contemporary Art (Berlin) Storefront for Art and Architecture (New York,) Fondation Cartier pour l'art contemporain (Paris) and Haus der Kunst (Munich). As founding partner of SBA Scheppe Böhm Associates, he was published Endcommerical® / Reading the City (Hatje Cantz 2002), a visual record of modern urban life which has been widely acclaimed in journals such as The New York Times, Domus, Art Forum and Kunstforum International. Recent book projects include KGID Konstantin Grcic Industrial Design published by Phaidon Press (2005) and Breeding Tables, a comprehensive publication examining a design project based on genetic algorythms by Kram Weisshaar (2005). Florian Böhm has designed for Vitra, Adidas Salomon AG, Benetton, LTU-Airlines, Tirol and Austria amongst others. He lives and works in Munich and New York City..

© **Photography** by Florian Böhm 2005

Vier5

A design studio, founded in Paris in 2002 by Marco Fiedler and Achim Reichert. The work of Vier5 is based on a classical notion of design, design as the possibility of drafting and creating new, forward-looking images in the field of visual communication. A further focus of their work lies on designing and applying new, up-to-date fonts. The work of Vier5 aims to prevent any visually empty phrases and to replace them with individual, creative statements, and develop them especially for the used medium and client.

rAndom international

rAndom international is a cross disciplinary design collective that was born in 2002 on a hill in Egham, Surrey. Three of the founders subsequently went to the Royal College of Art, the fourth man is a teacher in Brixton and a writer now. rAndom international is based in London and Berlin. Their latest projects are »Watchpaper«, a technology that allows them to print digital displays onto ordinary paper, and the Pixel Roller, a paint roller that lets you paint digital images from the internet, your phone, camera, etc. in one stroke onto your walls, floor and ceilings. Their work has featured in Will Alsops installation at the Valencia Art Biennale in 2003 [Erotic Confessional], they have done graphic design and development projects for Olafur Eliasson [2004], developed a Caviar Bowl Concept for Garrard, the crowns jeweller in London [2005] and are now creating the Graphics for the Egyptian Museum in Doha, Qatar.

Hannes Koch—Born in Hamburg [DE] 1975—finished school in 1995—BSc [Hons] Product Design, Brunel University, Surrey [UK], 1998–2002—MA Design Products, Royal College of Art, London [UK], 2002-2004—**Awards** OPOS Italian Designer under 35 Milan Furniture Fair, 2002—Audi Design Foundation Sponsorship, 2001—PERGO Flooring Design Award, 2002—Won competition to do the CI Egyptian Museum, Doha, Qatar, 2004—**Work Experience** Studio von Klier, Milan [IT], 1999–2000—MetaDesign, Berlin [DE], 2001—Freelance Graphic and Product Designer [UK and GER], 2004

Flo Ortkrass—Born in Lippstadt [DE] 1975—finished school in 1994—trained as a carpenter 1995-1998—BSc [Hons] Industrial Design Engineering, Brunel University, Surrey [UK], 1998–2002—MA Design Products, Royal College of Art, London [UK], 2003–2005—**Awards** Die Gute Form Award, 1998—Bentley Concept Award and Sponsorship, 2000—European Green Light Design Competition, 2002 [Finalist]—**Work Experience** Siemens Design, Munich [DE], 1999—Philips Design Eindhoven [NL], 2001—AUDI Design, Ingolstadt [DE], 2001—therefore Design, London [UK], 2002—Holtkoetter, Lippstadt [DE], 2002—Pearson-Lloyd, London [UK], 2003

Collaborative Projects and Awards—**Art Projects** dostoprimetschatjelnosti, Berlin [DE], 2002—Valencia Art Biennale, Erotic Confessional, 2003—KRAUT mobile newspaper, 2004—Operation: Schoener Ltd, 2005—**Trade Fairs and Exhibitions** Light Building, Frankfurt [DE], 2002—Spazio OPOS, Milan Furniture Fair, 2002—Valencia Art Biennale, in Will Alsops Department, 2003—Store in the Convento del Carmen, 2003—Detour Exhibition, Neon Gallery, London [UK], 2003—Designmai, Berlin [DE], 2005—New German Design, Hillside Terrace, Tokyo [JP], 2005—**Awards** Rosenthal European Competition, second Place, London [UK], 2004—Garrard Competition, 2004/05, Finalists, London [UK], pending—iF Design Award concepts 2005, Hannover [DE]—Rosenthal European Competition, second Place, London [UK], 2004

Photography and Instant Labelling Tape, Copyright Hannes Koch

Jim Lambie

Born in Glasgow in 1964 and worked in the music industry before studying at the Glasgow School of Art. He has exhibited widely and in 1998, received a British Council award towards a residency at Triangle in Marseille. In 2000, he received a Paul Hamlyn Foundation Award for Artists. Forthcoming projects include solo shows at Inverleith House, Edinburgh and at the Museum of Modern Art in Oxford. Lambie lives and works in Glasgow and New York.

Selected Solo Exhibitions—»Mental Oyster« Anton Kern, New York, 2004—»Grand Funk« OPA [MX], 2004—»Male Stripper« Museum of Modern Art, Oxford [UK], 2003—»Kebabylon« Inverleith House, Edinburgh [UK], 2003—»Acid Trails« Basel/Miami

Beach Art Fair, The Modern Institute, 2002—»The Breeder Projects« Athens [GR], 2002—»Salon Unisex« Sadie Coles HQ, London [UK], 2002—»Boy Hairdresser« Anton Kern, New York City [USA], Sadie Coles HQ, London [UK] and The Modern Institute, Glasgow [UK], 2001—»Blank Generation« Jack Hanley, San Francisco [USA], 2001—Konrad Fisher, Dusseldorf [DE], Triangle, Paris and Sonia Rosso, Pordenone [IT], 2000

»Zobop« Gold, silver, black and white vinyl tape, 2002—»Installation view, Early One Morning« Whitechapel Art Gallery, 2002—»Paradise Garage« black and white cross hatch gaffa tape, 2003—»Installation view: Zenomap« Scottish Pavillion, 50th Bienniale de Venezia, 2003—»Zobop« multicoloured vinyl tape, 1999—»Installation view: Voidoid« Transmission Gallery, Glasgow [UK], 1999—»Zobop« multicoloured vinyl tape, 1998—»Days Like These« Tate Triennial, Tate Britain, London [UK], 2003—»Zobop« monochrome vinyl tape, 1999—»Installation view: The Queen is Dead« Stills Gallery, Edinburgh [UK]

All pictures © Jim Lambie—Courtesy Gallery Sadie Coles HQ, London [www.sadiecoles.com] and Gallery Sonia Rosso, Torino [www.soniarosso.com]

Poni

Poni is a gang of dancers, artists, writers and musicians from various continents who operate from Brussels on the initiative of Frank Pay. As Poni describes it, »our work is experimental with codes, symbols and forms from every possible discipline«; –look at Poni as a mould that plays games on the skeleton of art, as a transformer that generates collective idiocy.

Rodolphe Coster June 28, Brussels [BE]—**Lieven Dousselaere** Born in 1977, somewhere between Ghent, Brussels [BE], my head and my toes—**Gudni Gunnarsson** 30 going on 20, currently working and living in Barcelona [ES] and Brussels [BE]—**Sinusjog** Born in 1979, Brussels [BE]—**Marc Lallemand** 33, Saint-Gilles [FR]—**Kate McIntosh** Born in 1974, Brussels [BE]—**Erna Omarsdottir** 31, Brussels [BE]—**Frank Pay** Born in 1968, Brussels [BE]—**Eric Tatepokembo a.k.a E.T** Born in 1973, Alie-Nation [?]—**Production** Margarita Production vzw, Brussels [BE]—www.margaritaproduction.be—**Video** Jesse van Bouwel—**Lights** Marco Lhommel—**Sound** Xavier van Werch—**Assistant Scenography** Kwinten Lavigne

Photography by Kristin Loschert and Kerstin Finger, al Mousonturm Frankfurt [DE], 2005

Chris Kabel

Born in Haarlem [NL], 1975—graduated in 2001 at the Design Academy, Eindhoven [NL]—moved to Rotterdam in 2002—works from his studio hear the Maas River—**Projects—2005** DSM gift for DSM [NL]—Souvenir d'Italie, for Case da Abitare and Alessi [IT]—**2004** Chi ha paura, What's Luxury, jewellery design—Levi's Europe, display and shop items design—Sofa foundation, the upholstered furniture project—Droogdesign, go slow presentation, Milan [IT]—table linen design, packaging—Royal VKB, tableware design—Museum Boijmans van Beuningen and Rio Tin, design of pewter table objects—Flames in moooi collection—…,staat Amsterdam, Remember me—objects for Levi's Vintage Collection—**2003** Lecture at ICA London, Heineken project—Interior objects for Mahler office building in Amsterdam [NL], Toyo Ito Architects with DRFTWD—[discontinued]—jewellery displays design for Concepts Jewels—Participation on Fifty/Fifty project by Famous studio for 100% Design Fair Rotterdam [NL]—Chandelier Project for Lille **2004**, Cultural Capital of Europe with Droogdesign, in collaboration with French Lace Industries—Project for Heineken Intl., Amsterdam [NL], sensorial marketing—Stedelijk Museum Amsterdam acquires 1totree chandelier—**2002** print tableware designs for Kahla Porzelan, Germany [DE]—Improvvisare Giapone Project, Tokyo [JP], for the Design Academy Eindhoven [NL]—Lowlands 2003, with Droogdesign, concept—Gerrit Rietveld Academy, Amsterdam [NL], lectures—Watch! jewellery stores, Breda [NL], packaging and gift-cheques—**2001** Tiara for princess Maxima Zorreguieta, organized by Stedelijk Museum het Kruithuis, 'sHertogenbosch [NL]—Interior materials for US Prada shops, Office of Metropolitan Architecture and Vincent de Rijk—**Competitions/**

Awards nominated for the Rotterdam Design Award 2003 with 1totree lamp—winner [twice]of the advertisement and culture competition by the Gasunie Netherlands, with movie script »Whose Culture« [2001] and »90° passing ships« [2004]

Beat Zoderer

Born in Zurich [CH], 1955—lives and works in Wettingen [CH] and Genoa [IT]—1971–78, apprenticeship and work in various architecture offices—since 1979, freelance artist—1982, grant from the Board of Trustees of Canton Aargau [CH]—1986, studio scholarship in Genoa awarded by the City of Zurich—assistant to Prof. Peter Jenny, ETH Zurich—1988 studio scholarship in New York from the City of Zurich—1989 - 1991, Swiss Federal Art Scholarships—1991, scholarship from the City of Zurich—1994 and 1998, one-year scholarship from the Board of Trustees of Canton Aargau [CH]—1995, Manor Art Award from Canton Aargau [CH]—1998, Acknowledgement Award from the Max Bill and Georges Vantongerloo Foundation, Zumikon [CH]—since 2000, member of the board of the Camille Graeser Foundation, Zurich [CH]

Solo Exhibitions from 1999—1999 Kunstverein Freiburg [GER], Bodenübung und andere Wandstücke—Maximilian Krips Gallery, Cologne [GER], Ein Schaufenster—Haus für konstruktive und konkrete Kunst, Zurich [CH]—Overbeck-Gesellschaft, Lubeck— Institut für moderne Kunst in der Schmidt Bank Galerie, Nurnberg [GER]—2000 Städtische Galerie Altes Theater, Ravensburg [GER]—Kunstverein Grafschaft Bentheim [GER]—Espai Pascual Lucas, Valencia, S.A. Vinyl—Thomas Taubert Gallery, Dusseldorf [GER], Ein Brimborium um ein DIN A4—Mark Müller Gallery, Zurich [CH], n.a. 99/00—2001 Projektraum WUK, Vienna [A], Die Früchte hängen immer hoch, installation—2002 Kunstmuseum Bonn, Pavillon Skulptur Nr. II, installation in video space—Museum Liner, Appenzell [CH], Kabinettstücke—Kunsthalle Winterthur [CH], Auslage—C-Art Gallery and Publishers, Dornbirn [A], Absenz und andere Räume—2003 Markus Richter Gallery, Berlin [GER], Stücke oder 12 kurze Bemerkungen über Malerei—Kunstmuseum Bonn [GER], Der doppelte Boden ist tiefer als man denkt—Fiedler Contemporary, Cologne [GER], Wand–und ein Bodenstück—Dina4 Projekte, Munich [GER], Eine neue Stütze der Gesellschaft—2004 Mark Müller Gallery, Zurich [CH], Tektur und andere Leerstellen—Wilhelm Hack Museum, Ludwigshafen [GER], Die Linie und ihre Folgen—2005 Markus Richter Gallery, Berlin [GER], Dialog—Dina4 Projekte, Munich [GER], Neue Arbeiten

Group Exhibitions from 1999—1999 Mark Müller Gallery, Zurich[CH], Direkt auf die Wand, Malerei V—Stiftung für Eisenplastik, Hans König, Zollikon [CH], Das Torero-Objekt—Maximilian Krips Gallery, Cologne [GER], Paintings—Centre Cultural Tecla Sala, Barcelona [ES], de coraz[i]ón—Galerie für Zeitgenössische Kunst, Leipzig [GER], Primary Structure— 2000 Kunsthaus Zürich, Zurich [CH], Carte de visite 3: Dada, Revival[s]—Kunstmuseum Singen, Hier, da und dort—Haus der Kunst, Munich [GER], Fin Raum für Robert Ryman—Kunstmuseum Bonn, Ein Raum für Robert Ryman—Fahnemann Gallery, Berlin [GER]—2001 Maximilian Krips Gallery, Cologne [GER], Farbe Schwarz-Weiss Hans A. Riirkle, Freiburg i. Br. [GER], Sammlung Rosskopf—PS, Amsterdam [NL], WOP Works on Paper—2002 Kunsthaus Aarau, Preisträger, Manor—2003 le Plateau, Frac, Ile-de-France, Paris [F], 20 ans D'1 Collection—Fiedler Gallery, Cologne [GER], New Order—2004 Florence Lynch Gallery, New York [USA], Minimal Pop—Dachgarten Südstadt, Cologne [GER], Privatgrün— Palazzo San Giorgio, Genoa [I], Vicini-oltre lo Sguardo—2005 Gallery Les filles du Calvaire, Paris [F], Minimal Pop—Atelier 340 Muzeum, Brussels [B], Le mouvement intuitif, bis—Watari-um Museum, Tokyo [J], Temporary immigration with Lars Müller and Silvia Bächli